SAYVILLE ORPHAN HEROES

THE COTTAGES OF ST. ANN'S

JACK WHITEHOUSE

THE
History
PRESS

For all those who helped to make the Cottages an American success story.

Published by The History Press
Charleston, SC 29403
www.historypress.net

First published 2010

Manufactured in the United States
ISBN 978.1.60949.094.2

Library of Congress Cataloging-in-Publication Data
Whitehouse, John H. (John Henry), Jr.
Sayville orphan heroes : the cottages of St. Ann's / John H. Whitehouse, Jr.
p. cm.
Includes bibliographical references and index.
ISBN 978-1-60949-094-2
1. Orphanages--New York (State)--Sayville--History--20th century. 2. St. Ann's Episcopal Church (Sayville, N.Y.)--History--20th century. 3. Church Charity Foundation (Brooklyn, New York, N.Y.)--History. 4. Whitehouse family. 5. Orphans--New York (State)--Sayville--Biography. 6. Heroes--New York (State)--Sayville--Biography. 7. Sayville (N.Y.)--History--20th century. 8. Sayville (N.Y.)--Biography. 9. Sayville (N.Y.)--Social conditions--20th century. 10. Sayville (N.Y.)--Church history. I. Title.
HV995.S462S78 2010
362.73'2--dc22
2010040435

CONTENTS

Acknowledgements 5

Introduction 7

The Beginning 9

The Germans and the Irish 12

The Whitehouse Hotel 16

The KKK Factor 21

Death Comes Calling 25

The Origins of the Cottages 29

The Gillettes 36

Those Who Came Before 45

The Roosevelts 55

The Cottages Become a Home 59

Who Were the Inmates? 62

Father Divine's Cottage Angels 65

Father Divine and the KKK 70

The Cottages and Reverend Bond 81

The Remarkable Mary Erhard 84

Paying the Bills 87

Everyday Life 94

More Than Just Sports 102

CONTENTS

Erhard Forced Out 109

Life After the Cottages 112

Join the Navy and Fly 118

The Family's Twenty-one-Year-Old Hero 122

Reporting for Duty, Sir! 125

Into Combat 129

The Battle for Iwo Jima 134

Danger to the End 138

Recognized Heroics Soon Forgotten 142

Epilogue 145

Bibliography 149

Index 153

About the Author 159

ACKNOWLEDGEMENTS

Many people helped me during the course of my research and while writing this book.

Most of all I want to thank my wife and editor, Elaine Kiesling Whitehouse, for going over the manuscript several times with a fine-tooth comb, checking and correcting the manuscript numerous times and for her steadfast belief in my seeing the project through to completion. The book would not have been possible without her.

I want to thank my son, John III, and his wife, Etsu, for their support, particularly with the technical aspects involved in the research and presentation of the material.

I would like to single out Cottages' residents the late Henry (Hank) Whitehouse and Mickey Walker (Eunice McGlynn) for their detailed and essential contributions. Hank, with whom I spoke at length many times over the course of more than a year, did so while suffering a terminal illness. I must also express my appreciation to Hank's gracious wife, Frances, for her contribution in providing some of the early family history. Of course I must also recognize my father, John Whitehouse, who, over the course of a lifetime, provided oral commentary for key portions of the story. Likewise, my mother, Betty Whitehouse, also contributed elements of the narrative that proved essential. Thank you also to my cousin Lucy Woodcock Spangler for her contribution.

I want to thank members of the Sayville Historical Society for their input and assistance. The society's president, Constance Currie, provided significant help with copies of pertinent news articles, Episcopal Church documents and leads to finding relevant information. Curator Linda

Conron was instrumental in providing a copy of Cottages Superintendent Mary Erhard's annotated collection of her columns in the Church Charity Foundation's monthly newsletter, the *Helping Hand*. Linda also put me in touch with Cottages alumna Mickey Walker and located several old photographs that have helped to tell this story. Program Chair Suzanne Robilotta arranged for me to speak about the Cottages to members and guests of the historical society. Following this presentation, local citizens Judy Stein and Ruth Travis came forward to provide leads to additional information. The late Charles H. Oelkers provided oral testimony about people and places in long-ago Sayville. Finally, I also want to mention society member John Wells for his contributions about the local sports teams and his encouragement in getting this project completed.

My thanks also go to Reverend Joseph Bond's children, particularly Peggy and Edith and also Skipper, for their advice, insights and information. I must also mention Reverend Bond himself, whom I knew both as St. Ann's rector and as my step-grandfather for more than thirty years, from the early 1950s until his passing in 1984. I also appreciate the assistance of many other members of St. Ann's Church, both past and present, too numerous to cite here by name.

Thank you to my friend Warren McDowell, soldier, newspaperman, volunteer fireman and longtime St. Ann's Sunday school teacher, for providing pertinent documents from the time of the Cottages. Thanks also to former Islip Town Councilman Christopher Bodkin for his knowledge of the town, his erudite conversation and for providing local texts that would otherwise not have been available to me.

Special thanks must go to my next-door neighbors and lifelong Sayville residents Al and Lois Bergen for their descriptions of life in Sayville in the 1930s and for their moral support in pursuing this project. Thank you to librarian Jeanne Demmers, who found and provided me with many books on Long Island history.

I want to thank Sayville library staff members Jonathan Pryer and Allan Heid for their always friendly and able assistance. Also, thanks to Mark Rothenberg at the Celia M. Hastings Local History Room at the Patchogue library for his extra efforts in helping me conduct my research. I must also express my appreciation to the research staff at the New York Historical Society library for their efficiency in helping me find old documents, studies and news articles within their extensive archives. I am also grateful to New York City Fire Museum Director Judy Jamison, who helped me find details of the Brooklyn Orphan Home fire.

INTRODUCTION

I did not set out to write this book. It all began one evening on a difficult ride home on the Long Island Rail Road. As the train passed through Jamaica I looked out the rain-streaked window and remembered that my father's family had lived not far from here, and that he and his three siblings suddenly had to move away. Somehow, my father, John Henry Whitehouse, his older brother Henry, younger brother Gilbert and the youngest child, Mary, ended up in an orphanage on the edge of Brown's River in the little town of Sayville. I began to write about some of the remarkable incidents in their lives.

Despite the family stories, I knew little about John's parents, their heritage or John's life before his thirtieth birthday. I had only heard family lore about how John's father's family had arrived in the New York City area from German-speaking Europe sometime in the mid-1800s and that his mother's Irish family had arrived at about the same time. Apparently, both families were part of that first great wave of European immigration to America that took place in the 1840s and 1850s, coming ashore somewhere in the New York City metropolitan area, possibly in Brooklyn. In fact, Flatbush Avenue is the location of the first physical evidence of the existence of either one of the families.

The heart of the story is that of four children growing up as "inmates" at the Church Charity Foundation (CCF) home for children in Sayville, a place known less formally as the "Cottages." The story reveals the early years of St. Ann's Church, its Episcopal priests and the South Shore parishioners who contributed to bringing the Cottages to Sayville.

The story looks closely at institutional life for these underprivileged and orphaned children and the remarkable people who cared for them. It

also touches on the supporting role of two disciples of African American evangelist Father Divine, the often-public presence of the Ku Klux Klan, the effects of the Great Depression and the unsung accomplishments of some prominent school and community leaders of the time. The final chapters focus on the three boys' duty in World War II, particularly Gilbert's as a U.S. Navy aviator and John's exceptional performance as a U.S. Navy fighter pilot in some of the fiercest battles in the Pacific.

In writing this book, I tried to shy away from too academic a presentation. I also made every effort to be historically accurate, but mistakes do happen. Indeed, over the past five years, I repeatedly revised parts of the text based on new information as it became available.

It is easy to be matter of fact about what the Cottages were, why they existed and who made them a success. But I hope the reader will also discover the underlying personal and societal value structures that made the Cottages and the people who grew up in them so successful. Children and adults alike made a continuous effort at mental and physical discipline, working hard at virtually every undertaking from school and church studies to physical labor and sports without any expectation of reward. No one seemed to have a sense of entitlement about anything.

I also found this population far less cynical toward our political, social and religious institutions, despite ample opportunity to find fault. Work for the church, service in the military, the anonymous donation of time and money for the general good all appear to have been common not so long ago.

THE BEGINNING

Henry Whitehouse Sr. was a bear of a man, with large hands, a barrel chest and a Teddy Roosevelt face. In a time of religious adherence, if not fervor, he was an agnostic, preferring self-reliance and hard work to guidance from above. Stubborn as he was bright, he did things his own way or not at all. He owned his own business, and while it was difficult making a go of it, at least he had no one to answer to but himself. Ultimately, he and his family would pay a price for his rugged independence.

In 1917, the Whitehouse Hotel, an establishment that today would be considered a bed-and-breakfast, stood on the empty shores of Jamaica Bay, in what was then called Hook Creek. Today the land is part of the eastern edge of JFK Airport across from the Inwood section of Nassau County. Hook Creek remains the name of the stream that empties into Jamaica Bay. It also provides the demarcation line for the Nassau County border with Queens.

Henry's hotel was open year round. During the nineteenth century, hotels, restaurants and spas on Long Island's South Shore—such as the Marine Pavilion in Rockaway Beach, the Dominy House, the Surf Hotel on Fire Island and Castle Conklin on Captree Island—were quite popular. People living in the city enjoyed the opportunity to venture out to Long Island, breathe the fresh salt sea air and go fishing for the plentiful blue fish, fluke and other bounty of the bays and ocean.

But in 1917 things were changing rapidly. The economy was moving toward the Roaring Twenties, and New Yorkers were moving from the city to Long Island on a permanent, year-round basis. For Henry Whitehouse, the future did not look bright. Turning fifty had caused him to take stock of where he was and where he wanted to be. He was not a poor man; he

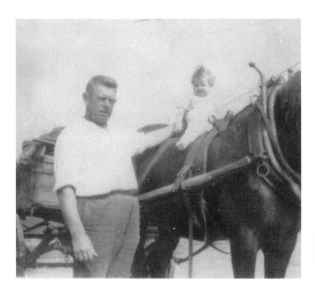

Henry Whitehouse Sr. with son John and the family horse in the summer of 1922.

owned the hotel and a brand-new Model T Ford and generally enjoyed a good standard of living. But he realized he soon would need help to keep his business going. He also wanted the wife and family he had never taken the time to acquire. In 1917, Henry met, and then courted, a sturdy yet attractive, intelligent woman considerably younger than he.

In 1917, Anna Tate was twenty-five years old, bright, single and childless. Raised in a strict Roman Catholic family, she was devout in her faith. She, too, was anxious to marry and have a family. Despite her fair Irish skin, black hair and blue eyes, her lineage and faith had kept her out of the sights of eligible bachelors. She hated the idea of becoming a spinster and feared that such a fate was not far ahead. Then, along came Henry.

Anna discovered that Henry, despite his stubborn personality, had compensating qualities she found irresistible. He always treated her with a combination of respect, affection and tenderness. Henry also provided financial stability and the physical comforts that came with operating his own profitable business. Finally, he had a sharp mind and interests similar to hers. So when Henry Whitehouse proposed marriage, she turned love's blind eye to his age and religion, or lack thereof, and accepted his proposal.

Henry was nominally a Protestant. If forced, he would admit to being of Lutheran descent, but organized religion had played no significant role in his life, nor was it about to. Henry's family had its roots in Germany. His parents had come to the port of New York long before the creation of Ellis Island, in about 1845. They arrived in desperate financial straits due to the prolonged

crop failures in Europe, part of a wave of other equally destitute German-speaking immigrants.

Between 1830 and 1860 a total of 1.36 million German-speaking immigrants entered the United States. But these immigrants came not only from the Germany we know today but also from Switzerland, Austria, Luxembourg and countries as far to the east as Russia, Ukraine and the shores of the Black Sea. People in the United States ignored the German speakers' countries of origin, referring to them all simply as German immigrants.

As with the U.S. population of the time, a majority of these new arrivals belonged to the Protestant religion. However, fully one-third were Roman Catholic, and a minority were

Anna Tate Whitehouse, circa 1921.

Jewish. This significant number of non-Protestant, German-speaking immigrants, together with their own cultural values, made the entire group greatly suspect in the eyes of the American citizenry. As with the rest of the German-speaking immigrant population, the immigrant Whitehouse family found this religious and ethnic intolerance a significant obstacle to overcome.

The German speakers generally moved as quickly as possible to leave their old identities behind in order to become fully accepted Americans. They changed their names to anglicized versions and adopted most of the customs of English-speaking Protestant America. While no one knows for certain, Whitehouse family legend holds that Henry Whitehouse's parents began life with the German last name of Weisshaus and translated it directly into English.

So when Henry decided to marry a poor, Irish Roman Catholic, it was family heresy. Such a union would take the family back decades—to lower-class status and the social stigma they had sacrificed so much to escape. The Whitehouse family would have none of it.

THE GERMANS AND
THE IRISH

How in democratic and free America could a family ostracize its own son, and another family its own daughter, simply for marrying someone from another Christian faith and a different European background? It happened to Henry Whitehouse and Anna Tate, and in the late nineteenth and early twentieth centuries in America it happened to many others. The reasons behind such tragedies are woven into the fabric of the American history of the period.

Prejudice against the immigrant Irish of the late nineteenth and early twentieth centuries was significant. Perhaps not as well known is that during this time Protestant America viewed the German-speaking immigrant population—like Henry's early immigrant family—as equally worthy of distrust. Many in Protestant America suspected that a good percentage of these German-speaking immigrants owed their true allegiance to the Pope in Rome. And how could anyone tell which German speaker was Catholic and which not? Many good Protestant American citizens decided it was best not to trust any of them.

In the mid-nineteenth century, this deeply ingrained Protestant American distrust of poor continental European immigrants, particularly the Irish and the German speakers, became pervasive. This uniquely American malady became known as *nativism*.

Nativist politics came to the forefront in America coincidentally with the arrival of the Whitehouse and Tate families in the United States in the mid-nineteenth century. In the 1850s, the nativist movement developed into the American Party, attracting more than one million members nationwide. Popularly, the party became known as the Know-Nothings because whenever a member was asked about party activities he was supposed to reply, "I know nothing."

Following the 1850s, most of the American Party membership, on Long Island and elsewhere in the North, became part of the Republican Party. In the South, the American Party allowed Roman Catholics to join and functioned as the primary alternative to the Democratic Party.

The advent of the Civil War and the coincidental demise of the Know-Nothings did nothing to diminish American nativist beliefs. The primary political parties, always seeking popular support, adopted American Party proposals as their own. In 1882 Congress passed a law banning the immigration of paupers and convicts. Literacy tests, as a methodology for preventing voting by non-English speaking immigrants, came into vogue in many locations. As the nation approached the twentieth century, many Americans began to suspect that recent immigrants, particularly the German and Irish, not only caused labor unrest by accepting jobs for minimal pay but also were secret members of communist, socialist and anarchist movements bent on instigating trouble.

In the latter half of the nineteenth century and first third of the twentieth, nativist beliefs strengthened even more. The primarily Protestant, English-speaking population viewed the rampant and growing political corruption in major city governments as a direct result of the political activities of new immigrants.

In the late nineteenth century, New York City's own Tammany Hall became the shining example of what nativists opposed. Tammany Hall (the name Tammany comes from *Tamanend*, a Native American tribal leader) is physically located on Fourteenth Street in Manhattan, and the Tammany Society dates to the 1780s. But the popular name Tammany Hall actually refers to the Democratic Party political machine that the society became in the 1800s.

In the mid-nineteenth century, Tammany Hall began to gain political control by earning the support of the huge influx of German and Irish into New York City. They did this by helping the new arrivals get jobs and a place to live and by organizing efforts such as voter registration drives. As early as 1854, Tammany Hall had become an all-powerful Democratic Party political machine inside New York City politics. The machine's powerful leaders, or "bosses," were so entrenched that they felt free to engage in all manner of corrupt practices. William M. "Boss" Tweed became the most infamous and visible of targets for nativist adherents, even well past his political and personal demise in the 1850s. Tammany Hall politics and its "services" for the lowest-paid workers continued to prosper even into the middle of the twentieth century.

Long Island could not avoid the Tammany Hall influence. Summer resort towns such as Sayville served as playgrounds for some of the better-known characters. Mayor Jimmy Walker—who, along with the forty-second governor of New York, Al Smith, visited Sayville frequently—was infamous not just for political corruption but also because of the large number of speakeasies his administration tolerated during the era of Prohibition and his numerous affairs with city chorus girls. Historian Charles P. Dickerson wrote, "On his parlor shelf was the little tin box where you deposited the money if you wanted a favor from the infamous Mayor Jimmy Walker. It was in Sayville that Mayor Walker handed his resignation to the City Clerk." Walker eventually left his wife, Janet, for chorus girl Betty Compton.

And so in the early twentieth century, in New York and the surrounding countryside, the prevailing perception among the relatively well-to-do, majority white Protestant citizenry was that those of Irish (Walker was of Irish descent) or German lineage, and the people who closely associated with them, were not first-class citizens. Respectable people viewed these immigrants as susceptible to supporting a corruption of the American democratic process. They believed the immigrants were not to be trusted.

To counter the influx of such undesirables, more and more federal laws were passed restricting and even in some situations banning immigrants from certain countries. For example, Congress prohibited immigration from China in 1902. In 1907, President Theodore Roosevelt concluded a "gentleman's agreement" with Japan to exclude immigrants from that country altogether. Efforts to restrict the immigration of others from countries such as Russia, Poland, Hungary and Italy soon followed.

In the years preceding the April 1917 U.S. entry into World War I, American sentiment turned increasingly anti-German. As a result, many people and organizations with German roots did what they could to hide their lineage. An example is cited an August 8, 1918 article from *The New York Times* concerning a string of recent fires on the Brooklyn waterfront. It says, in part, "The Customs Intelligence Department is investigating numerous reports regarding the Germans at large in South Brooklyn who have access to the piers. Marine insurance brokers pointed to the fact that all the recent explosions and burnings of ships and cargoes have occurred in that part of the waterfront." Of course, World War I was ongoing at the time, but obviously it was not good to be a "German-at-large."

Thus, from the mid-nineteenth century through the period following World War I, it made sense to many families in America—the Whitehouse family included—to appear as white and Anglo-Saxon Protestant as possible. But

stubborn Henry Whitehouse chose to ignore such societal forces, deciding to go ahead and marry his beautiful Irish Catholic girlfriend Anna Tate regardless of what the rest of his family believed. At the time, he did not realize how much he and his future family would have to pay for his bold, if not courageous, decision.

Anna Tate, from a close-knit Irish family background, had been brought up as a firm believer in all the dogma of the Roman Catholic Church. For someone with her family and background, a marriage outside the faith was not acceptable, either to the church or the family—and all the more so when the marriage was to be with an agnostic of German lineage.

Ironically, German immigrants and their Irish cousins shared many of the same problems in integrating into American society, but for a variety of reasons the two groups were often at odds. For Anna, this divide made her situation with Henry very difficult. While she probably thought she could convince her family to accept her decision to marry Henry, in reality it was a notion born of wishful thinking and simply not to be. Anna's family completely rejected her intentions and, in a pique of terrible anger and frustration, said goodbye to her forever.

As for Henry, he would at least maintain contact with his sister Henrietta, her husband and their two daughters. The family history is not clear about whether Henry and Henrietta were twins. From what is known, they were both about the same age and apparently always very close. It was much more common to give two children names like Henry and Henrietta if they were born together.

For Anna, the schism was complete; no one from her family ever saw or spoke with her again. The Roman Catholic church in the Inwood Section of Nassau County was more forgiving. Anna attended Mass there every Sunday, and when her children were old enough, she took them there. Anna would remain a member of that congregation until the end of her life.

THE WHITEHOUSE
HOTEL

Life at the Whitehouse Hotel was good, and Henry and Anna settled into a warm and loving relationship that would produce four strong children. On June 10, 1919, Anna gave birth to Henry Whitehouse Jr. (Hank) in the couple's bedroom at the hotel. A little over two years later, on October 15, 1921, a second son, John Henry Whitehouse (John), came into the world in the same room. Gilbert Albert (Bud) was the third son, born January 27, 1923, and Mary Adele (Mary), the only girl and the youngest child, was born July 25, 1924.

Despite the absence of an extended, supporting family and with the ethnic discrimination of the day, the Whitehouse family prospered, enjoying their close-knit family life. Anna had been well brought up and made every effort to impart to her children the manners and behavior of decent and respectable people. She spent every moment she could with them, instilling discipline while never letting them forget how much she loved them.

Hank's earliest memory of his mother was in, of all places, the barroom of the hotel in the summer of 1923. Two of the men in the bar were amused by Hank's precociousness, and each encouraged him to say bad things about the other. Anna soon discovered what the men were up to and gave them an earful. More than sixty years later, Hank maintained that he could still hear his mother's voice in that incident, as if she had just finished speaking.

Hank and John shared a lifelong memory from their early existence at the seaside hotel. Both men remembered that the family owned a goat, and both told the story of the goat as though it was his own. In Hank's version, he decided one day to take the goat down to the edge of Jamaica Bay. He tethered the animal there and left to do something else. When he came back

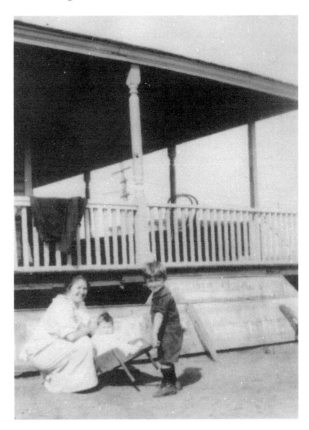

Anna Whitehouse with sons Hank and John (in wheelbarrow) in front of the Whitehouse Hotel in the summer of 1922.

to fetch it, the tide had come in and the unfortunate creature had drowned. John's version of the story is almost identical, also ending with the sad demise of the goat. The incident made a lifetime impression on both men. Each man always regretted this childhood lesson; i.e., learning the value of life by discovering what it feels like to take life away from an innocent creature.

Running a hotel business in the 1920s on Long Island included staying in touch with friendly competitors. Henry and Anna, well aware of this business maxim, spent time encouraging those who might recommend their hotel. One such cooperative facility was the Kiesling Hotel located in New Hyde Park, at what is today 600 Jericho Turnpike and now known as the Nassau Inn. As the crow flies, the Kiesling Hotel was only about six miles due north of the Whitehouse Hotel in Hook Creek and an equal distance, only in an easterly direction, from Jamaica, Queens.

Like Henry, the proprietors of the Kiesling Hotel were of German descent, a heritage that significantly facilitated a friendly relationship. This

relationship between the two Long Island hoteliers, informal and limited as it surely was, would produce an ironic twist for both families. Part of the irony is that no known contact existed between the two families until almost a half-century and one generation later, when Jack Whitehouse, John's son, married Elaine Kiesling in 1968.

Unfortunately, neither Anna nor Henry discussed with the children, or anyone else for that matter, the families to which they had belonged before becoming married. The estrangement probably mattered little to Hank, John, Gilbert or Mary, who knew only their present situation. The only reminder of any larger family unit was the occasional friendly visit with Henry's sister Henrietta and her family.

Henrietta was married to Christian Schaefer, also of German-speaking heritage and the Lutheran faith. The Schaefers had two daughters, Etta and Margaret. But Christian Schaefer had found success in life more difficult to attain than Henry. He and his wife and daughters lived sparingly in a small apartment one block from the Long Island Rail Road Station in Jamaica, Queens. He took work when and where he could find it. A visit to Henry's hotel, particularly in the midsummer heat, must have been a big treat.

In 1920, not long after his return to New York from World War I duty in the Atlantic with the U.S. Navy, John Sander married the Schaefers' oldest daughter, Etta. The young couple began married life in a small apartment in Brooklyn while Margaret, the Schaefers' younger daughter, remained with her parents in Jamaica. Not many years after the marriage, Etta became seriously ill and passed away. John Sander eventually remarried to Etta's younger sister Margaret. John and Margaret Sander would become the only family the Whitehouse children would know.

John Sander, a kindly, soft-spoken man loved by all who knew him, also came from a German-speaking background. He grew up in New York City's German Town, or Yorkville as it is now called, and attended PS 158 at Seventy-eighth Street and York Avenue in Manhattan. The school is still there and is still educating youngsters, with major renovations never undertaken. Today the street sign on the façade of the building says "Avenue A," which is what York Avenue used to be called many years ago.

John Sander must have learned about the pre-1919 Whitehouse family history, as painful as it may have been to talk about, either from his wife's parents or directly from Henry and Anna. Yet, for whatever reason, John Sander could never bring himself to relate one word to Hank or John, or anyone else.

Today almost nothing is known for certain about the Whitehouse family origins prior to the 1919 birth of Henry Whitehouse Jr. at the Whitehouse

The Cottages of St. Ann's

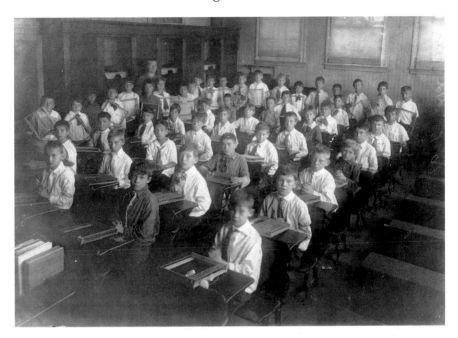

John Sander's class at PS 158 at Seventy-eighth Street and York Avenue in Manhattan. The photo was taken circa 1910. John Sander is seated, the seventh boy back in the third row.

Hotel. What little is known comes from oral commentary and a single faded photograph. No written record exists of the dates of birth for either Henry Sr. or Anna. John and Hank simply insisted that Anna was born in 1892 and Henry Sr. in 1868 or possibly 1867. Neither man could cite any particular source for their knowledge of these dates. Similarly, no known record exists of Henry Sr. and Anna's wedding; no one even knows where either of them is buried.

How could there be so little known about the Whitehouse family before 1919? They were intelligent people who left almost no physical evidence of their existence and almost no record of their early lives. In fact, the only proof of the existence of the Whitehouse family in the United States as early as the mid-nineteenth century is a single photograph found a number of years ago in the belongings of John Sander's second wife, Margaret. The photograph, taken at the Gross Bros. Portrait Shop at 176 Atlantic Avenue in Brooklyn, shows a well-dressed couple of about thirty years of age posing quite formally. Penned in an unknown hand on the back of the photo, in a style of script used many years ago, is the following:

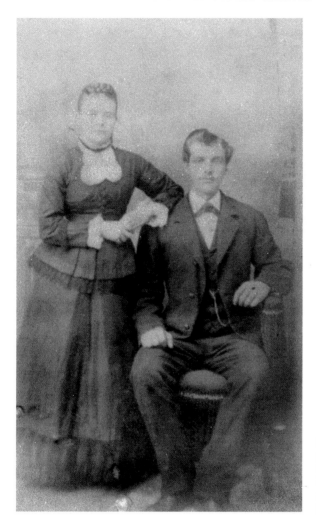

Photo of the Whitehouse great-grandparents taken circa 1850 at the Gross Bros. Portrait Shop at 176 Atlantic Avenue in Brooklyn.

John H. Whitehouse's Grandparents Married in the 1850's

Why is so little known about the Whitehouse family history before 1919? At least part of the answer may lie with a genuine smudge on the American character. The discrimination embodied in nativist thinking was bad enough, but in 1915 a more sinister aspect of the nativist movement became plain for all to see in the rebirth of the Ku Klux Klan.

THE KKK FACTOR

Reflecting popular sentiment and increasing nativist political pressure, from 1917 to 1924 the federal government enacted a string of new laws designed to place limits on the number of immigrants allowed into the United States. In 1924, Congress passed the National Origins Act establishing blatant discriminatory immigration quotas. For example, the law allowed for more than 65,000 British immigrants per year, but no more than about 5,800 from Italy, 2,700 from the new Soviet Union and almost no Asians whatsoever. Congress then passed additional laws totally excluding poor German, Soviet and Asian immigrants.

The post–World War I period was a time of tremendous growth on Long Island. It also brought with it anti-immigrant pressure against anyone who could be labeled a "foreigner." The labor movement, powerful at the time, demanded immigration restrictions. Labor movement leadership claimed that cheap immigrant labor was keeping American workers' wages from rising. Many people, not just union members, seemed to believe that too many immigrants would ruin what was becoming a very strong economy— an economy that would come to be known as the Roaring Twenties.

The nation's dark mood toward outsiders—some describe it as nativist paranoia—was such that it led to the formation in 1915 of an organization known as the "new" Ku Klux Klan (KKK). The "new" KKK preached anti-immigrant, anti-black, anti-Catholic and anti-Semitic policies while at the same time voicing strong support for law and order, the Constitution of the United States and traditional white Protestant values. It spoke out against radicalism, liberalism and nonconformists of all sorts, as well as political, judicial and police corruption.

On Long Island, the KKK stressed its support for the enforcement of laws to curb serious societal ills including rumrunning, speakeasies, gambling, drug use and "houses of ill repute." The KKK found a generally receptive audience to its law and order message, especially when other political and social organizations seemed to be turning a blind eye to the problem.

The overall KKK message of "us against them, real Americans against the forces of darkness" appealed to many hardworking, churchgoing white Protestant citizens, not only on Long Island but around the country as well. People who were increasingly perplexed and concerned with the rapid changes the Roaring Twenties was bringing to American society were looking for change.

The new Ku Klux Klan was different from the KKK of the post–Civil War period or the hate group of today. In fact, from the 1860s to the present, there have been at least three different organizations using the name Ku Klux Klan, with most historians saying there were many more. What, then, was the history of the new KKK, and what brought it to Long Island in the 1920s?

On December 24, 1865, a small group of men meeting in the law office of Judge Thomas M. Jones in Pulaski, Tennessee, founded the original Ku Klux Klan. This was the infamous secret paramilitary organization known for its violence against blacks and others who disagreed with the concept of white supremacy in the old South. Reportedly, the group derived its name from the Greek word *kuklos*, meaning a circle, and *klan* came from the Scottish word clan. Only three years after its founding, this original klan organization began to go into decline and by 1874 was destroyed as an organization, thanks in part to the federal government's vigorous action against it under the Civil Rights Act of 1871. This new law allowed the federal government to take individuals to trial for violations of civil rights when states refused to prosecute.

Close to half a century later, in late November 1915 at Stone Mountain, Georgia, a one-time paid promoter of fraternal organizations named William Simmons formed the new Klan. Simmons and his assistants organized the new KKK to include national, state and local party structures. Local chapters of the KKK sprang up almost overnight all over the country. The "kleagles"—the term used for the new KKK's organizers—sold memberships in the organization to white, Protestant, native-born males eighteen years old or older. They offered white, Protestant, native-born women eighteen years old or older auxiliary membership. By late 1923, the Long Island KKK claimed 20,000 members. Nationwide, by 1925 during its

heyday, approximately 5 million American men had joined. The entire U.S. population in 1925 was a little over 110 million, so a 5-million-man party was not inconsequential.

The new KKK used a variety of techniques to try to sell itself as a legitimate political party. One of those was to use the Protestant churches of cooperative ministers as recruiting venues. The new KKK called Protestant ministers who supported their cause, and who allowed proselytizing from their pulpits, "kludds." Many Long Island churches openly supported this new KKK. For the clergy, in places where the Klan was popular, church attendance markedly increased, and that was something the clergy could not easily dismiss. Church officials also liked the Klan's outright gifts of money. The April 13, 1923 edition of *The Suffolk County News* reported on a Klan recruitment meeting held at the Cedarshore Hotel at the foot of Handsome Avenue in Sayville on the evening of April 11. The Reverend Mr. Moore, a Baptist clergyman from the South, spoke about the Klan to a crowd estimated at 1,000. In his talk, Reverend Moore claimed the Klan had "more than 30,000 Protestant preachers enrolled" nationwide.

Another new Klan technique for lending the organization legitimacy was its publication of a scholarly monthly newsletter called the *Kourier*. The July 1927 edition of the *Kourier*, which sold for ten cents a copy or one dollar per year, dedicated itself to a discussion of the "religious qualifications" of New York State Governor Alfred E. Smith for the office of president of the United States. The main article, written by Dr. H.W. Evans, Imperial Wizard, is entitled, "For the People or for the Pope?" In the piece, Evans asks if Smith owes his allegiance to Pope Leo XIII or the United States. He goes on to detail the purported dangers that come from Roman Catholic power in U.S. government. A footnote says the article is the third in a series by Dr. Evans on the dangers of foreign ideas, principles and purposes that could win control of America through the conquest of the Democratic Party.

Fortunately, the new Klan eventually began to appear less attractive to American citizens who, as the KKK described them, "believed in preserving America for real Americans." Beginning in the late 1920s, Congress investigated financial corruption within the organization, resulting in the closure of its national offices. The new Klan's popularity also dropped with the coming of the Great Depression, in part because of the demonstrated financial crimes committed by the organization's most prominent members. Membership fell precipitously with the advent of World War II because of the KKK's support of the German Nazi Party.

But given the public sentiment represented by the KKK of the 1920s, it is not difficult to understand why John and Hank might have only vague understandings of their family's early origins and history. Henry and Anna knew an Irish Catholic or German-speaking heritage was not something to advertise if they wanted access to all the benefits of first-class, white Protestant citizenship for their children. These caring parents would not have imbued their children with stories about their family and their heritage in the same manner as perhaps a Dutch Reformed or British Anglican family might have done. No, Henry and Anna knew all too well that it was much better to mask their German-Irish lineage from the children in order to better protect them from any possible bigotry or discrimination that came with such a heritage.

DEATH COMES CALLING

The good life at the Whitehouse Hotel for the prospering Whitehouse family was destined not to last. For a number of reasons, including the arrival of a fourth child, a move by South Shore hotel patrons to build their own summer homes and his advancing age, Henry Whitehouse decided to sell his hotel. By 1925, the sale of his business completed, Henry moved his growing family to a large house at 8 Soper Street in Oceanside. As the crow flies, Oceanside sits only about five miles due east of Hook Creek. The house is still there.

In early 1926, only about a year and a half after the birth of their fourth child, tragedy struck. On a cold and damp winter's day, Anna became ill with what seemed to be a bad cold. Within days the chest cold grew much worse, developing into pneumonia. Lying in her bed, her breathing increasingly ragged, she must have begged Henry to do something to make it easier for her to breathe. Henry, feeling helpless as he watched his beloved wife's life ebb away, tried everything to save her, but to no avail. Only five days after contracting the illness, Anna Whitehouse slipped away in the early hours of the morning, dead at the age of thirty-five.

Hank and John, at the time of Anna's illness, were only about seven and five years old, respectively. They could hear their mother's coughing and occasional pleas for help that could not come. With her death came many nights of tears and eventually the terrible understanding that their mother was never coming back. But the fates were not finished with the two little boys; the worst was still to come. Neither of them could imagine how soon they would have to learn about becoming self-reliant and alone in the world.

The last years had been difficult for both Anna and Henry. After Henry sold his business, he took a job as a Nassau County deputy sheriff working

at the Nassau County jail in Mineola. The pay was not great, but together with the profits from the sale of the hotel, he earned enough to keep the family going. With a little luck, he thought, they might just make it. But luck is always hardest to come by when it's needed most.

Anna, on her deathbed, worried about what would become of her four precious children. She knew that her almost sixty-year-old husband could not possibly care properly for four young children without any other family member, or family money, on which to rely. Their only other adult relatives, Henrietta and Christian Schaefer, were in their sixties and not in good health; their daughter Etta lived in a small apartment in Brooklyn, and daughter Margaret could not be expected to take on the burden of caring both for her parents and four young children. Anna may have known that Henry was himself in declining health and not in a position to carry on for too much longer. She probably imagined that the prospects for her little ones were bleak indeed. How hard she must have prayed that somehow God would take care of her family and especially her beloved children! We will see how God seems to have taken His time but ultimately answered her prayers.

For his part, Henry was heartbroken at his wife's passing and deeply worried about what the future would bring. Soon after Anna's death, he learned what he had suspected for some time: he was dying of a slow-growing cancer. He decided that his only recourse was to get the Schaefer family—Henrietta, her husband Christian and their youngest daughter Margaret—to come live with him and his four children at the Soper Street house. There was plenty of room; in fact, the address consisted of two houses, the main house and number 8A, which was a bungalow located behind the main house. Henry built the bungalow himself, a structure the children liked to call the "tiny house." He built it for the rent money it could provide.

The stress of Anna's sudden demise worsened Henry's difficult and prolonged battle with cancer. But despite his agonizingly slow and painful deterioration, for the sake of the children he remained stoic to the end, finally passing away quietly in the main bedroom of his Soper Street home. He died in the arms of his oldest son. For the rest of his life, ten-year-old Hank would carry with him the memory of that sad moment and the promise he made to his father to take care of his younger brothers and sister.

Fortunately, Henry Sr. had had a dear friend—possibly through his work as a Nassau County deputy sheriff—named Claude Van Deusen who, in 1929, was a retiree from a senior position with the Nassau County welfare bureaucracy. From his work, Van Deusen knew many of the people who

The Cottages of St. Ann's

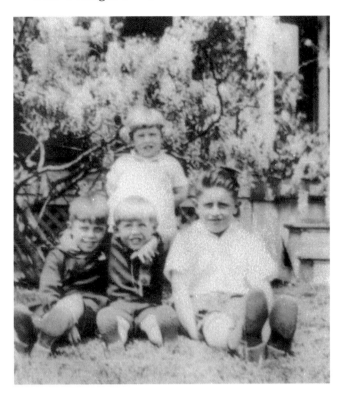

Pictured are the four Whitehouse children in front of the Soper Street house, probably in the summer of 1928.

worked for the Church Charity Foundation (CCF), a large charitable organization under the guidance and leadership of the Long Island Diocese of the Episcopal Church. Van Deusen was also familiar with the CCF's success with its brand-new children's facility located in Sayville. He had explained to Henry about a place called the "Children's Cottages," convincing him it would be the best long-term solution for his soon-to-be orphaned children.

Following Henry Sr.'s death in late 1929, Van Deusen completed arrangements for all four children to be placed in the Cottages. On a frigid Valentine's Day in 1930, he loaded John and Hank into his car for the long drive out to Sayville. There he left them in the Cottages, the place they eventually learned to call home. Younger brother Gil and sister Mary stayed behind in Oceanside with friends and neighbors until they were old enough to join Hank and John.

One can only imagine the terrible sense of abandonment these two young children felt as they entered the Cottages. Over a relatively brief period of time, the boys had suffered the loss of their mother and father, became separated from two of their siblings and were permanently removed from

their family home and all their childhood possessions. They were thrown into a totally new environment with only the familiarity of each other.

The experience surely molded John's character in ways that even he never completely understood. Elements of his adult personality reflected some of it. He became tougher than most and not afraid to take a risk. He rarely complained about any physical or mental discomfort that would have caused many others to whine and moan. He tended to distrust authority figures, and he occasionally showed a ferocious temper when sufficiently provoked. He readily shared possessions but was a packrat, refusing to throw anything away. In a recent study of "hoarding behavior," one packrat put it this way: "People walk out of your life. Things don't." A fear of abandonment, if indeed that was part of his personality, is certainly understandable.

Fortunately, a warm and kindly older woman known to the children as "Miss Sanford" went out of her way to welcome Hank and John to their new home. Miss Sanford worked something of a miracle in making these two children feel safe and wanted, laying the groundwork for the boys' future happiness in their new home. For the rest of his life, Hank remembered her as one of the kindest people he had ever known. We do not know how John felt about her because John refused to talk to anyone about that time in his life. Unfortunately, no known written record of Miss Sanford exists.

An educated guess would make Miss Sanford either the housemother for the boys' cottage or possibly an interim Cottages superintendent. She occupied the position only briefly between the five-year tenures of the Episcopal nun, Sister Dorothy, and the very capable widow of an Episcopal minister, Mary Erhard. Claude Van Deusen, who was a friend indeed, held the town of Hempstead's office of "Overseer of the Poor" as late as 1912 and possibly past that date.

In summary, one can see how the political, religious and social conditions and public perceptions of the time contributed to the division and separation of the Henry Whitehouse family from their extended family. Perhaps one can better understand how the Whitehouses and the Tates could so completely reject Henry's marriage to Anna Tate—even to the extent of never seeking contact with the four innocent and wonderful children their tragic union produced. It also gives some explanation as to why the details of the families' origins apparently have been lost forever. Finally, it sets the stage for what became a rather remarkable story of love, compassion, beneficence and payback in the little town of Sayville.

THE ORIGINS OF
THE COTTAGES

The charitable organization responsible for the Cottages in Sayville originated in Brooklyn Heights in 1850. That year, approximately a half dozen women from the newly incorporated Grace Church of Brooklyn Heights undertook the care of three indigent women. After trying unsuccessfully to place the women in private homes, the Grace Church ladies rented a small house on Brooklyn's Love Lane to house them. The charitable efforts of Mrs. Henry E. Pierrepont, Mrs. Sarah Richards, Mrs. George Hastings, Mrs. Sarah Gracie and others quickly gained public attention that brought about suggestions for a more formal and comprehensive arrangement.

In January 1851, after at least two organizational meetings, including one at the office of the mayor of Brooklyn, members of Grace Church and others decided to incorporate. On February 6, 1851, at a meeting in the Episcopal Church of the Holy Trinity, the Church Charity Foundation (CCF) became a reality. All the Episcopal clergymen of Kings County (Brooklyn) were named to the CCF Board of Managers. This group then elected lay managers and a Board of Associates to direct the charity's activities. The Reverend Francis Vinton, the first rector of Grace Church in Brooklyn Heights, became the foundation's first president.

The charter issued in 1851 to the CCF by the legislature of the State of New York stated in part that one of the organization's primary goals was "to found an Institution or Establishment for the relief, shelter, support protection and education of Indigent Orphans, and half-orphan children and such other Children as the Providence of God shall have left in a destitute or unprotected state and condition."

In pursuit of this goal of protecting needy children, in the early 1850s the CCF rented a house on Carlton Avenue in Brooklyn while it planned the construction of a more permanent facility. In 1858, church officials laid the cornerstone for a "Home for the Aged and Orphan" on land purchased by the CCF at the corner of Albany Avenue and Herkimer Street in Brooklyn. On January 6, 1860, the CCF dedicated the brand-new three-story structure where needy children would live for the next fifty-six years.

The following late nineteenth-century timeline shows when other significant Episcopal Church and CCF changes took place:

- In 1868, Bishop Horatio Potter created the Episcopal Diocese of Long Island from what had been part of the Diocese of New York with eighty-five clergy and thirty-five parishes.
- In 1868, Bishop Potter named Reverend Abram Newkirk Littlejohn as the first bishop of the Diocese of Long Island and president of the CCF. He would oversee much of the philanthropic development of the CCF and serve as bishop until 1901.
- In 1869, the CCF started in offices on the Brooklyn property a monthly paper called the *Helping Hand*. The CCF described the paper as printed and published every month by the orphans of the CCF home.
- In 1876—and again in 1884—the CCF enlarged its Orphan House, enabling the facility by 1884 to house more than one hundred children.

During his tenure, Bishop Littlejohn inaugurated the involvement of Episcopal Church sisters in the running of CCF institutions. The sisters, dressed in their habits, took daily charge of the CCF's various facilities, including the orphan home, and the Episcopal Church Sisters coordinated the activities of each department with the CCF Board of Associates.

But the Church Charity Foundation's Orphan Home did not operate in a vacuum. In the latter half of the nineteenth century, other churches, civic organizations, businesses and private individuals throughout the New York metropolitan area worked hard to provide poor, sick and orphaned children with the means to survive. The mid- to latter half of the nineteenth century saw a tremendous increase in the number of needy children, particularly in New York City. Causes included the arrival of large numbers of very poor European immigrants, the draft riots of 1863 responsible for the deaths

of more than two thousand New Yorkers, contagious diseases, drug and alcohol addiction and the Civil War, during which so many young fathers were lost and families financially ruined. New York City, particularly lower Manhattan, became the epicenter for destitute and homeless children.

Tom Riley, in his book *Orphan Train Riders: A Brief History of the Orphan Train Era (1854–1929)*, points out that in the latter half of the nineteenth century homeless children "wandered the streets of the city in search of meager scraps of food and shelter. They engaged in gambling, drugs, prostitution, theft and murder. Untimely deaths of parents, sickness and addiction to alcohol and drugs left thousands of orphaned children. The complete absence of social services and access to medical care that we know today caused a huge influx of people cast into the streets because of non-payment of rent or death of a household figure."

Despite major efforts to alleviate the problem, the orphanages and criminal detention facilities, especially in New York City, simply could not care for the legions of destitute and orphaned children. The situation became a humanitarian crisis of significant proportions, a festering sore that would only get worse before it got better.

While private and religious organizations stepped in to do what they could to help alleviate the suffering, charity leaders faced difficulties combating the crisis. Money and resources were scarce. Real estate in the cities had become expensive, and donors and taxpayers alike had limits as to how much money they could make available for building and staffing more child-care facilities.

In 1853 came the formation of the Children's Aid Society of New York City. Twenty-six-year-old Methodist minister Reverend Charles Loring Brace (1826–1890), a Brahmin from the refined New England town of Litchfield, Connecticut, became the organization's unlikely first leader. Reverend Brace quickly became a tireless advocate for the welfare of New York City's homeless children.

Riley reports that Reverend Brace personally helped 100,000 youngsters get foster and adoptive homes. He set up schools and lodging houses for both boys and girls. He provided sanctuary for African American children during the New York draft riots of 1863. He also established New York's first free kindergarten, played an instrumental role in getting compulsory education laws passed and pressed for the acceptance of women into medical colleges.

Reverend Brace preached that the salvation of New York City's homeless children lay with family life in the nurturing small-town environment to be found in America's villages west of the big city. He achieved the removal of homeless children from the city and their placement in "good Christian

homes" in the countryside located farther west. Brace emphasized that the children should not become servants or apprentices to families needing workers; rather, they should become part of the family in their new homes.

By the early twentieth century, New York City orphanage managers, led by men such as Reverend Brace, had picked up an estimated 200,000 homeless children off the streets of the city. Customarily they provided each child with a bath and a new set of clothes and placed him or her on a train headed for a rural location. Most of the orphan train children got only as far as the Midwest before being "adopted," but some traveled even as far as Alaska.

At each stop along the normal routes, guardians took the children off the train for inspection by interested local citizens. Of course, abuses occurred. As expected, a few prospective "parents" were simply looking for extra hands to help with the farm or housework. There were other problems, too. For example, brothers and sisters became separated with no chance of ever reuniting, and occasionally the adoptive family sent the child back. But the majority of children were well received and found a new life with a caring, loving family.

Thanks in great measure to Reverend Brace and other visionaries, the early decades of the orphan train era were also the formative years for the creation of the "cottages plan" concept. While Reverend Brace and others devoted themselves to relocating homeless children to families in the countryside, they also recognized that there could be benefits to shifting at least some of the burdens of the still overcrowded city orphanages to the less populated surrounding communities.

Reverend Brace began with a small experiment, and perhaps with a concept borrowed from the wealthier classes. In 1875, he opened a summer home where orphans and the children of the street could spend a week at the seaside. The idea seemed to work well and set the stage for much bigger projects.

By the turn of the century, the New York Orphan Asylum Society and others had adopted a new concept in orphan care. The thought was to combine the best aspects of both the orphan trains and the city orphanages by building home-like orphanages, or cottages, in the open air of the countryside where space, financial, safety and health considerations could allow for better child care in a more controlled environment. It was an idea whose time had come.

Church Charity Foundation Director Reverend Paul F. Swett, who served as director from 1904 until his death in 1922, knew the pressing need for the CCF to find a solution to the problems of overcrowding in its Brooklyn

facility. He also saw the number of needy children rising almost on a daily basis and felt pressured to find some way to provide assistance to even more children. Expansion of the orphan home seemed the only answer; however, a surge in property values in Brooklyn made additional land prohibitively expensive. Also, wealthy donors, already contributing substantial sums of money, could not realistically be asked to contribute much more.

Then Swett heard about the "cottages" concept. Instead of housing children in often dirty, cramped city dwellings, he learned that a few institutions had opened large houses, or "cottages" as they were called, in the countryside. Swett visited several of these facilities in the New York metropolitan area and came away impressed with the success of these less expensive, better appointed non-city facilities. He became convinced that the cottages concept was something the CCF might employ to try to solve its problems. Then came the sudden and completely unexpected incident that would forever change the Church Charity Foundation's children's care program.

Early in the evening of March 30, 1916 the actions of one small boy changed the history of the CCF and the futures of more than one hundred needy children. The March 31, 1916 edition of *The New York Times* described in some detail the harrowing events.

At 5:15 p.m. on the evening of March 30, 1916, ninety-three of the ninety-five children living at the Church Charity Foundation home had just sat down to dinner. Two youngsters did not come to the table because they had been restricted to their upstairs rooms as punishment.

Church Charity Foundation Director Reverend Paul F. Swett. *Courtesy of Warren McDowell.*

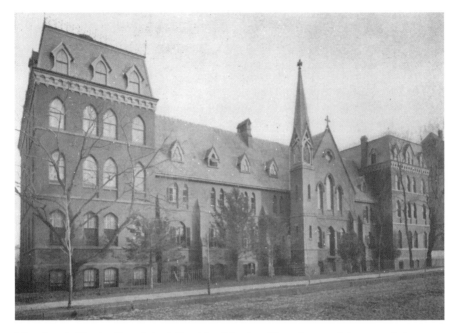

The Church Charity Foundation's Brooklyn "Orphan House" around the turn of the century. *Courtesy of Warren McDowell.*

According to the *Times*, at approximately 6:00 p.m. a house leader ordered George Zutell, a normally well-behaved nine-year-old boy, to take dinner up to the one restricted boy on the second floor and the other on the third floor. Gone from the dining room for only a matter of minutes, the next time anyone saw George Zutell he was running full speed out the front door yelling, "Fire!" Soon a thick cloud of acrid black smoke engulfed the room.

While all the children and staff in the dining room managed to escape quickly and safely, there was no sign of the two confined boys or two of the staff who had been relaxing in their upstairs rooms.

Within minutes, a combination of heroics and luck permitted the authorities and several passersby to save all four people trapped on the upper floors. But the fire damage to the second floor of the home was extensive, and there was also heavy smoke damage on the first and third floors. The cost for repairs would be at least $25,000.

Later that same evening, George Zutell confessed to police that he had found some matches on his way up the stairs, lit one and tossed it into the second-floor linen closet. He told police he had no idea what had made him do it.

Immediately after the fire, the one hundred or so children under the CCF's care were transferred to other institutions in the New York City area or to their nearest relatives. Thus, beginning in April 1916, after fifty-six years of caring for needy children, the CCF children's department was—at least temporarily—out of business. The burned orphan home was demolished and the site used for the new Home for the Aged and the Blind, which was dedicated in 1917.

The decision to move the Orphan Home to the countryside seemed the only logical answer. The question was where the house, or "cottages," should be built.

The CCF decided that the small Long Island hamlet of Sayville would be the site for its new child-care facility. But how did the CCF come to that decision, and why? After all, Sayville was almost fifty miles east of the CCF's Brooklyn facility. The answer is that a significant number of unusually gifted people set the stage for the creation of the Cottages. Of all those people, one remarkably generous and civic-minded church family stands out above the rest; that family's name was Gillette.

THE GILLETTES

Prior to the Civil War, Dr. George R. Brush (1836–1894) and his wife, Margaret Ann Smith Brush (1841–1918), bought the property in eastern Sayville on which the CCF's Children's Cottages would eventually be built. When Mrs. Brush passed away, leaving no other heirs, Ida Gillette, a cousin of Mrs. Brush, inherited the property. In April 1921, Ida Gillette made public her donation of the land to the CCF for the purpose of building a child-care facility in the memory of Margaret Brush, who in 1879 had lost her only child, George Jacob Brush (1868–1879), to an early death.

Who was this wealthy Sayville citizen, and how did she come to be what the *Suffolk County News* called, at the time of her death on August 3, 1936, Sayville's Grand Old Lady? Ida Francesca Gillette was the eldest daughter of Charles Zebulon Gillette (1827–1906), a merchant mariner, born in Blue Point, and raised on the South Shore of Long Island. He began his seafaring career on board a ship captained by Isaac Snedecor (1837–1914) of Bayport, who, interestingly enough, was the patriarch of what would become one of the founding families of St. Ann's Church.

Gillette quickly mastered celestial navigation and piloting and after only a few years left Snedecor's employ, a fully qualified first mate. Then, with the financial assistance of his brother-in-law Austin Roe of Patchogue, Gillette purchased his own merchant ship called *Neptune's Bride*. Until the early 1860s, he sailed the profitable U.S. coastal routes and back and forth to the Mediterranean.

In 1847, Gillette married Phoebe Edwards (1829–1912), the great-granddaughter of John Edwards (1738–1826), one of Sayville's original inhabitants. Charles and Phoebe had three children, with Ida the couple's

first child. Phoebe gave birth to Ida on November 20, 1851, i.. still stands about one hundred yards south of Gillette House. The on.₅ John Edwards house, now the home of the Sayville Historical Society, is only about a quarter mile south of Gillette House.

With the outbreak of the Civil War, *Neptune's Bride* became of interest to the Union forces as a transport vessel. Thus, in early 1862, in the port of Baltimore, the government purchased Gillette's ship. Gillette then went to New York, where, through an unusual turn of events, he was asked by the U.S. Navy to take the cargo ship *John F. Farland* on a dangerous supply mission to the Gulf of Mexico.

Despite the dangers, Gillette accepted his country's call to serve. He immediately set sail from New York Harbor and safely piloted the *John F. Farland* into the northern Gulf and a rendezvous with Flag Officer David G. Farragut's fleet of about twenty fighting ships.

In the Gulf, Farragut commanded the West Gulf Blockading Squadron, a part of the Union's so-called Anaconda Plan. The idea was to blockade all Confederate ports to try to starve the South into submission. Farragut and his fleet had orders to enter the Mississippi River, capture New Orleans and cut off its commerce. To secure New Orleans, Farragut needed to run his fleet past Forts Jackson and St. Philip, a potentially disastrous course of action because of the probability of devastating fire from their powerful guns. After a commando raid was able to cut the Confederate's thick chain spanning the river, and after six days of shelling both forts, Farragut was finally ready.

In late April 1862, in the wee hours of a dark morning, Farragut ordered his fleet upriver. As expected, his ships came under heavy cannon and mortar fire. Farragut's flagship, the USS *Hartford*, was at one point disabled when a fire raft hit the ship and flames damaged the masts and rigging. Farragut later described the fight as "one of the most awful sights I ever saw." Remarkably, Captain Gillette's ship dodged all the fire rafts launched by the Confederates and he was also able to keep his ship from being hit by any of the forts' fusillade of cannon and mortar fire.

On April 25, despite the intensity of the battle, the fleet safely reached New Orleans and immediately occupied the city. With their avenues of escape cut off, on April 28, 1862, the Confederate forces manning Forts Jackson and St. Philip capitulated, giving Flag Officer Farragut his complete victory.

Following the victory, Farragut reportedly made a call on Captain Gillette aboard the *John F. Farland* to express his appreciation for a job well done. On July 16, 1862, the government thanked Farragut and promoted him to the

rank of rear admiral, making him the first officer to ever achieve the rank of admiral in the U.S. Navy.

That summer, Captain Gillette retired from life at sea. He returned permanently to his home on the Lane (now Gillette Avenue) in Sayville. He worked as a partner with his brother-in-law Captain Jacob Smith establishing the popular three-story Grand Central Store overlooking what is now Sayville's Sparrow Park. The self-educated Gillette also found time to serve for eight years as Islip town supervisor while at the same time holding the position of Sayville postmaster.

We know that the Gillette family were members of Reverend John Henry Prescott's St. Ann's Church, but when the association with the Episcopal Church began is unclear. It probably began with Reverend Charles Douglas at St. John's in Oakdale, but evidence of that has not been located. In any case, it seems apparent that for decades the Gillettes and their three children—Ida Francesca, Charles Edward and Lucille Preston (in birth

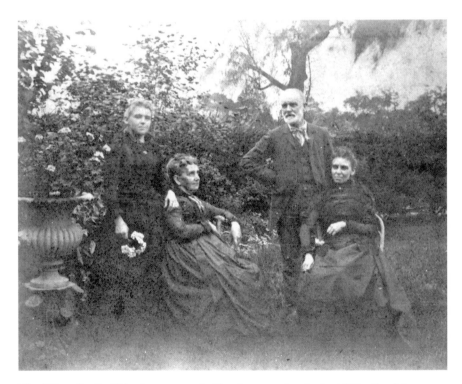

The Gillette family. This photo was probably taken sometime in the 1890s. *From left*: daughter Lucille, mother Phoebe (née Edwards), father Charles and daughter Ida. *Courtesy of the Sayville Historical Society*.

order)—all shared their belief in supporting the charitable good works associated with the Episcopal Church.

In early 1888, tragedy for Captain Gillette came when his thirty-year old son, Charles E. Gillette, died from tuberculosis. Then, in 1906, the popular Captain Gillette passed away, followed by his wife Phoebe in 1912. The next year, forty-six-year-old Lucille went to her grave, leaving Ida the sole surviving Gillette. At sixty-two years of age, Ida Gillette, without heirs, inherited the family fortune.

Ida set about contributing to her beloved South Shore community. She enlarged and improved the house her father had built, planting rows of pine trees around the grounds, trees that still grace the property to this day. She worked as one of the Sayville library's first trustees, serving on the board from 1914 to 1922. Ida became an active member of the Women's Village Improvement Society (now the Sayville Village Improvement Society, or SVIS), an organization responsible for important community work, including the 1924 purchase of the Sayville beach for $5,000. At the time of her death, and for many years before that, she served as the society's president. In 1916, she became one of the original members of the Sayville Garden Club, donating her own money for the maintenance of Sayville's once beautiful rows of elm and tulip trees.

At some point, reportedly in the early 1930s, Ida Gillette arranged for the people living on the land across the street from Gillette House to move to other quarters. She funded the removal of the two residences, opening up the space to create Gillette Park, now called the Common Ground at Rotary Park.

Like her father, she maintained an avid interest in political affairs and supported the Republican Party. One can imagine that she lobbied strongly in favor of women being granted the right to vote, which came with ratification of the Nineteenth Amendment to the Constitution in 1920. On the south side of Main Street, in about 1935, she donated valuable property to the Sayville Republican Club as a memorial to her father. The Republican Party used the land to construct the club building that still stands today.

In her last will and testament, and according to her parents' wishes, Ida Gillette left Gillette House and its property to the CCF for use as a "home for aged and needy persons to be known as 'The Gillette Home.'" Her will also provided for the construction by the CCF of other buildings on the property as necessary to care for needy convalescent persons. She asked for it to be known as "The Lucille Home for Convalescents," named in memory of her younger sister. Miss Gillette also willed the money necessary to bring about both projects. Finally, she gave St. Ann's Church $2,000 as a memorial

gift from her mother and bequeathed Sparrow Park to the Town of Islip, along with a fund of $500 to provide for its maintenance.

In the years following her death, the CCF tried but was unable to keep the Gillette property. In the late 1930s, the CCF attempted to turn the house into the Gillette Home, according to Ida's last will and testament, but failed to win the required approvals. Approvals were similarly not available for "The Lucille Home for Convalescents." Without an alternative use for the property, in 1944 the CCF donated the property to the Town of Islip. Eventually, the property came to be used as it is today for ball fields, with the once well-appointed house a meeting place for the Sayville Village Improvement Society and other civic organizations, including the Greater Sayville Food Pantry and BAFFA (Bay Area Friends of the Fine Arts).

So that was how, by the time of her death in the summer of 1936, Ida Gillette had become Sayville's "Grand Old Lady"—except for the most important part of our story, which remains to be told.

Local lore says that Ida Gillette had read a newspaper account of the 1916 CCF orphan home fire and immediately was moved to offer her assistance. Probably early on in the five years between the devastating March 1916 fire and the April 1921 public announcement of her gift, Ida Gillette let the CCF know that she would be willing to donate to it her land across the street from St. Ann's Church. At least one source indicates that Ida's offer stood for some time before the CCF was ready to accept the offer and commit to building a child-care facility according to the "cottages plan."

The Friday, April 8, 1921 edition of *The Suffolk County News* carried the following front-page story:

Sayville to Have an Orphanage
Miss Gillette Gives $25,000 Site
For Episcopal Charity
Will Be Opposite St. Ann's

Institution Supported by Church Charity Foundation
Will Be Built on Cottage Plan
Complete in Two Years Perhaps Sooner

Miss Ida Gillette has given to the Church Charity Foundation a site for an Episcopal orphanage which will be built here and supported by the Diocese of Long Island. Several years ago the Brooklyn orphanage was destroyed by fire and the Diocese has been waiting for a favorable time to rebuild.

The Cottages of St. Ann's

The property which Miss Gillette has given is valued at $25,000. It has a frontage of 1,000 feet on the south side of Main Street opposite St. Ann's Episcopal Church and an approximate depth of 400 feet. The institution will care for both boys and girls, probably fifty or more in number. It will be built on the Cottage plan and will be constructed sometime within the next two years; possibly if all goes well, work may begin in a few months.

Miss Gillette has long been interested in the good works of the Church Charity Foundation, among which is St. John's Hospital in Brooklyn. She recently refused an offer of $20,000 for the property she has given the orphanage.

In addition to the property acquisition, the CCF had raised at least some of the money necessary to begin construction. However, in early 1922, the driving force behind the reestablishment of the CCF's Children's Department and construction of new facilities, CCF Director Reverend Paul F. Swett, passed away. His death caused a significant delay in getting the construction of the Sayville project started until his successor could be chosen and familiarized with the project.

Finally, on Sunday October 28, 1923, ground was broken for the first cottage. Dr. H. Beeckman Delatour, a well-known surgeon affiliated with the CCF's St. John's Hospital, gave a brief talk. He explained that the CCF Home for Children in Brooklyn had been destroyed by fire and that Miss Gillette's generous offer had made the Board of Managers' majority decision to move the site for a new home from Brooklyn to the country an easy one. Delatour said that funds were already provided for the first building, which was estimated to cost about $40,000. He said well-known Bayport contractor Charles Breckenridge was to begin work at once. Finally, he warned, "The institution was not to be known as an orphanage as it was intended to provide a suitable home for any needy children of the Long Island Diocese."

A group of about fifty to sixty people watched Ida Gillette firmly plant her spade and remove two small squares of sod. She then placed a bouquet of flowers to mark the spot where the first cottage would be built. Reverend Joseph Bond, rector of St. Ann's Church, provided the blessing and thanked Miss Gillette for her generous gift.

The cornerstone for the first cottage—the one that faces west and is now called the Bishop Burgess Cottage—was set in place approximately one month later on December 1, 1923. The building was designed to house 20 girls, a housemother and an assistant. The Right Reverend Frederick Burgess officiated at the cornerstone-laying ceremony for what at the time was called "The Brush Memorial." An estimated 250 people from Episcopal parishes

all over Long Island attended the event. As part of the program, a variety of items were placed in a copper box in the cornerstone of the building. Among them were news clippings about the founding of the Cottages and information about the donation of the Brush property.

With the girls' cottage under construction, renovation was started on the house known as "Gray House," which came with the property. The Gray House stood due north of the Burgess Cottage close to Middle Road. The builders refurbished and enlarged Gray House to make it suitable for housing several boys and a housemother.

By the end of June 1924, the builders had completed their work. Both the girls' cottage and Gray House were ready to accept children. It had been eight years and three months since fire had destroyed the Brooklyn home for more than one hundred children.

On July 5, 1924, the first seven "inmates," as the children were referred to in the media and in the official 1930 Islip Town census, began their new lives at the Cottages. The numbers would grow rapidly. On October 18, 1924, the Right Reverend Frederick Burgess, bishop of the diocese and president of the CCF Board of Managers, dedicated the two Sayville houses, invoking God's blessing on the work to be done there.

The Gray House and the Bishop Burgess Cottage, circa 1924. *Courtesy of Warren McDowell.*

The Cottages of St. Ann's

A news article from an unnamed paper dated January 29, 1925, says that the Burgess Cottage housed eight girls, with eight boys living in Gray House. The same news article also says all the Children's Cottages' inmates were between the ages of five and twelve and mentions that they were looked after by Episcopal Church Sister Dorothy. Sister Dorothy's brother was the Reverend Charles Henry Webb, the director of the Church Charity Foundation, who took over the directorship following the death of Reverend Paul Swett. Sister Dorothy remained in charge for the first five years of the Cottages' existence, retiring in 1929. None of the Whitehouse children would ever meet her; she passed away in 1932.

Construction of the Canon Paul F. Swett Memorial Cottage for boys began in September 1925. Bishop Burgess presided over the laying of the cornerstone ceremony. The bishop and the CCF Board of Managers saw to it that the building's cornerstone, located on the northeast corner of the structure, perpetuated Reverend Swett's name. The cornerstone is inscribed with "1925" on the eastern face and "In memoriam PFS" (Canon Swett's initials) on the north side. In June 1926, the Swett Memorial Cottage was completed and ready for occupancy. In late April 1928, the then bishop of the Long Island Diocese, Ernest M. Stires, performed the building's dedication.

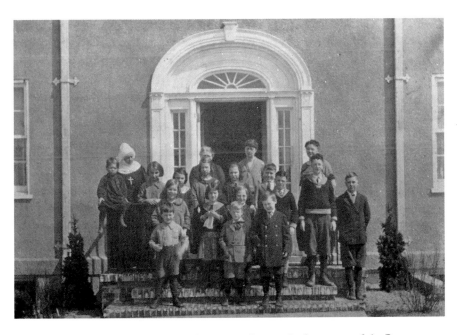

The inmate population in the spring of 1925 standing on the front steps of the Burgess Cottage. The nun is believed to be Sister Dorothy. *Courtesy of Warren McDowell.*

From July 1924 until the Canon Swett Memorial Cottage became ready to accept children in June 1926, the CCF used the two-story Gray House as the boys' residence. However, it appears that with the opening of the new Swett Cottage, Gray House became the residence for the older girls. No further reference to the structure is seen until Cottages Superintendent Mary Erhard writes about it in November 1932 in the CCF publication, the *Helping Hand*. She says that five of the high school age girls and a housemother whom Erhard calls Mrs. Buchanan are living there. No known record exists as to when this building was erected or when it was torn down or why.

Like the Burgess Cottage, the Swett Cottage was designed to house twenty children, a housemother and an assistant. On the ground floor in the center of the cottage was the common room, just as it is today. On the south side of the common room is a single bedroom. This became superintendent Mary Erhard's room in late 1932 when, with no governess available, she had to take charge of the boys' cottage; later, the room became caretaker Robert Cioffi's living quarters. Just to the east of the common room was the dining room, with its large fireplace and access to the kitchen that still stands at the southeast corner of the building. Most of the other rooms were bedrooms for the children, with the older boys in the rooms on the first floor and the younger boys relegated to the rooms on the second floor.

The timing for the establishment of what became known as the Children's Cottages, or simply the Cottages, in Sayville could not have been better— just before the start of the Great Depression, when economic hardship had never been as severe or widespread. People of all ages and educational levels suffered, with many families unable to provide even the essentials of adequate food and shelter for their children. In fact, a significant majority of the inmates were not orphans but half orphans or from families that could not afford to raise them.

An understanding of these circumstances makes it all the more startling to realize that for an important social program such as the Cottages there was never any local, state or federal government involvement: no money, no healthcare, no quality of care inspections, no licensing. The government provided nothing. On the contrary, because the children were not considered legal residents of Sayville, and New York State law said a financial charge could be levied if the school system required it, Sayville Schools charged the CCF $100 per year to educate each child. The CCF, a number of generous individuals and private organizations, the Sayville community at large and a handful of other dedicated individuals funded and managed the entire Cottages operation. What brought about such a display of charity in the little hamlet of Sayville?

THOSE WHO CAME
BEFORE

Ida Gillette gave the land, but in the early 1920s many others helped to provide the funding necessary to construct the actual cottage buildings. In 1933, then Cottages superintendent Mary Erhard wrote in the CCF's monthly newsletter the *Helping Hand* that a Mrs. Huber of Bay Shore contributed much of the money for the first of the Cottage buildings. Other news articles say the money came to the diocese from a variety of sources.

One non-attributed 1933 newspaper article says that the late Edwin Gould, millionaire philanthropist, gave significant money to the Episcopal Diocese of Long Island designated for the funding of the cottage buildings. Edwin Gould was the son of Jay Gould, the very wealthy principal owner of the Erie Railroad. In 1923, in great measure because of offers of condolence from many children for the accidental shooting death of his son, Edwin Gould founded the Edwin Gould Foundation for Children. The organization is still doing philanthropic work to this day.

Indicative of Gould's continuing support for the Cottages is a paragraph Mary Erhard wrote for the *Helping Hand* in the summer of 1933. She wrote, "Thirteen of our girls and four small boys…were guests of Mr. Edwin Gould at Camp Pocahontas, near Spring Valley, N.Y. for the whole term of the school vacation. We are very grateful for Mr. Gould's interest and have written him of our appreciation." Edwin Gould passed away not long after Mary Erhard's expression of appreciation.

News articles and Mary Erhard's diary point to the substantial charitable giving to the Cottages project by Ida Gillette, Edwin Gould, Mrs. Huber and other wealthy individuals of the day. The story of the Cottages also includes the financial contributions of many other, unnamed individuals of lesser

means within the Long Island Diocese and particularly St. Ann's Church. In fact, the inspiration for such giving, from big and small donors alike, may be traced to those who made up the St. Ann's congregation long before the start of the Cottages project.

Charles G. Stevenson in his book *But As Yesterday* describes the tradition at St. Ann's of parishioners and friends of the church contributing to the common good. Ironically, much of the information for Stevenson's book came not from official church records or senior church officials but from a diary kept by Sarah Elizabeth (Libby) Homan (1848–1897), a charter parishioner of St. Barnabas's Chapel from the time of its construction. Similarly, so much of what we know about the Cottages did not come from diocesan records or Episcopal priests and nuns but from a diary kept by parishioner Mary Erhard written more than half a century after the Homan diary.

The tradition of St. Ann's parishioners' contributing to the common good may be said to have had its start on March 16, 1866, when Mr. John R. Suydam (1807–1882) and his wife, Ann, wealthy summer residents of Bayport, purchased twelve acres of land north of Middle Road and west of the marshes for $550 from Mr. and Mrs. James M. Edwards. The idea behind the acquisition was to provide the local community with the opportunity to build a new Episcopal Church facility.

Initially at least, the precise purpose of this new facility was somewhat ambiguous. Stevenson wrote that beginning in 1863, the Reverend Charles Douglas (1833–1915), rector of St. John's Islip (now Oakdale), dreamed of building an Episcopal "Daily Parish School" in Sayville. To that end, in August 1864, Reverend Douglas arranged to rent the upstairs of St. John's parishioner Andrew D. Foster's Foster House, located at today's 74 South Main Street in Sayville.

Mr. Andrew D. Foster (1826–1907), described by Stevenson as "the most colorful pioneer" in St. Ann's early history, began life in Sweden as Petersen Forsslund and was almost certainly born into the Lutheran faith. He came to America in 1846, landing in New Orleans, where he soon heard of the California gold rush. Off he went again, managing to get to the gold fields via the Isthmus of Panama, which he crossed on foot before catching a ship headed north.

By 1853, after almost three years of mining gold and spending all he had found, Foster decided to pull up stakes and start all over again. He moved back east to New York City, where, as his luck would have it, he purchased a winning lottery ticket awarding him four plots of land near Ronkonkoma. But Foster, on seeing his land, decided he didn't like what he saw and so

moved south to discover what Sayville had to offer. There he met and married Ann Elizabeth Brown, a descendant of the prominent local Brown family, with Reverend Charles Douglas performing the ceremony.

For the next fifty-three years Andrew Foster would enjoy a profitable and productive life in Sayville. For twenty-five years he operated Sayville's one and only tailoring business. In 1864, he built the original part of the Foster House, where he ran a successful candy and ice cream store. In 1870, he enlarged the Foster House, furnishing it as a hotel and restaurant, which he ran until 1886, when he leased it to others. He also purchased eighteen acres of land in southeast Sayville and was the driving force behind having Foster Avenue opened as a public thoroughfare. In 1883, he built a Sayville summer resort, the seventy-five-room Delavan Hotel located on Foster Avenue. The Delavan became one of the most popular late nineteenth-century resorts on Long Island. (The hotel burned on January 1, 1933. The home at 274 Foster Avenue now sits on the property. The house at 272 Foster Avenue called "The Delavan" was an annex to the original hotel and was built after the hotel.)

It was on the top floor of the Foster House, where in 1864 Reverend Douglas started his parish school, calling it St. John's Academy.

A St. John's Academy school pamphlet advertising the 1865–66 school year describes the school as a "Classical, French & English Seminary For Young Ladies and Gentlemen." The pamphlet says that for admission "apply to the Rector," cited as Reverend Chas. Douglas. Tuition per twenty-two-week term was ten dollars for the Preparatory Department, sixteen dollars for the Intermediate Department and twenty dollars for the Academic and Collegiate Department, the latter promising instruction in ancient languages, higher mathematics, natural sciences and French. The announcement did not address religious instruction of any kind but said "Instruction in Vocal Music given to all pupils, free of charge."

Stevenson mentions a May 14, 1915 *Suffolk County News* article concerning the burial of Reverend Douglas that provides Reverend Douglas's motive in founding the school. The portion of the article cited states: "Because the public school was of none too high a standard, Mr. Douglas established a parish school on the upper floor of what is now known as the Foster House. Among his teachers were the late Reverend R.P. Hibbard and Miss Lawson, who later became Mrs. Douglas."

Mr. John R. Suydam and other Episcopal Church parishioners who contributed the money necessary to make the school a reality probably shared Reverend Douglas's civic-minded concern about the importance of a

good liberal, non-sectarian education for all children. The school curriculum remained nondenominational throughout the school's existence.

Reverend Prescott must have been well aware of Reverend Douglas's school and the concept of St. Ann's caring for children in more than just a religious sense. Thus, it appears that the idea of the Cottages at St. Ann's, agreed to by Reverend Prescott some forty-five to fifty years after St. John's Academy, would not have been an unprecedented concept either for him or for many of his parishioners.

Stevenson wrote that on June 18, 1866, after approximately two years in the upstairs of the Foster House, John R. Suydam advanced the sum of $700 toward building what Reverend Douglas envisioned as a school and chapel on Suydam's Middle Road property. In the early fall of 1866, workmen completed a wooden structure, Gothic in design, at a cost of between $2,500 and $2,700—with Mr. Suydam having advanced the church over $1,600 for the purpose. On completion of the wooden structure, Reverend Douglas moved his St. John's Academy from its home atop the Foster House to the Middle Road facility, thus making the new structure St. John's Academy.

On November 1, 1866, Mr. Suydam and his wife, Ann, conveyed the property and wooden structure to Reverend Douglas for $1,600, receiving in return a "purchase money mortgage" for the purchase price payable on November 1, 1871. The first service in the new wooden facility took place on November 7, 1866. Interestingly, Stevenson wrote that it was not until several months later, in 1867, that the name St. John's Academy was dropped and St. Barnabas's Chapel—the appellation chosen by Reverend Douglas—became the sole name for the new building.

St. Barnabas's self-sufficient "Daily Parish School," as it was called, remained open through most of the 1870–71 school year but ceased to operate at an unspecified date during the spring semester due to the inability to retain a suitable instructor. During the six and a half years of its operation, enrollment remained at between twenty-one and forty students, with some coming from as far as Islip to attend.

For the first four years of the school's existence, the pretty, blonde-haired Isabella Lawson had been Reverend Douglas's right arm in establishing and running the school. Miss Lawson also helped the reverend as the church organist and as a Sunday school teacher, affording these two accomplished young people a great deal of time together. When she left in the summer of 1868 to return to Albany, Reverend Douglas must have been at a loss as well as possibly heartbroken. In fact, he appears to have tried very hard to get her

to return, even telling parishioners in the summer of 1869 that he expected her back. But she did not come back.

By the fall of 1869, things appear to have taken a definite turn for the worse for the apparently forlorn Reverend Mr. Douglas. According to Mr. Stevenson, "Mr. Douglas reported to the 3rd Convention of the Diocese of Long Island held on May 17–18, 1870, that he had been ill for more than five months during the previous year and had been absent from the Parish part of the time." Is it possible he spent that time in Albany?

At the following year's Diocesan Convention held on May 16–17, 1871, Reverend Douglas reported, "For the past few months the Parish school had been closed for want of a suitable teacher but we hope to resume again soon."

Miss Lawson would not return, and the school would not reopen; in fact, in the fall of 1871, Reverend Douglas resigned from St. John's and left Long Island. Then, only one week after leaving St. John's for a parish in New Jersey, the reverend married the beautiful Miss Lawson, the woman who must have been his longtime, secret sweetheart.

One is left to imagine what small-town intrigue must have caused Miss Lawson to leave her school, church and beloved minister and move back home. For Reverend Douglas, the love of Miss Lawson must have meant a great deal for him to say goodbye to his cherished school, a success story that had been a personal dream come true. For the love of Isabella, the reverend also left behind his brand-new St. Barnabas's Chapel and a growing body of South Shore parishioners willing to contribute what they could to make him and his chapel a success. But neither Miss Lawson nor Reverend Douglas ever forgot their time in Sayville. Today, Isabella and Reverend Charles Douglas, husband and wife, are together forever, buried side by side in St. Ann's Cemetery.

After Reverend Douglas, several pastors attended to local services until 1873, when the Long Island Diocese of the Episcopal Church assigned the Reverend John Henry Prescott as missionary to St. Paul's Patchogue and St. Barnabas's Chapel in Sayville.

Mr. Stevenson wrote that in 1872 Reverend Douglas and his wife, Isabella, deeded the church property to the trustees of the estate belonging to the Diocese of Long Island, in trust to the congregation worshipping at St. Barnabas's Chapel. Then, in 1875, the trustees conveyed the property to the rector, church wardens and vestrymen of St. Ann's Church Sayville. In 1878, Mr. John R. Suydam forgave the $1,200 remaining on the mortgage as well as a $300 second mortgage, leaving the church free of any substantial long-term debt.

Mr. Stevenson points out that John R. Suydam's wife, Ann Middleton Lawrence Suydam (1823–1870), was a force for good in her own right. She was the third great-granddaughter of William Tangier Smith, who, in the late 1600s and early 1700s, was the sole owner of approximately forty thousand acres of eastern Long Island, including all of Fire Island (Great South Beach) and the Great South Bay. Ann Suydam was also the great-grandniece of General William Floyd of Mastic, a signer of the Declaration of Independence.

Mr. Stevenson wrote that the name change from St. Barnabas's to St. Ann's came "at the request of John R. ySuydam," in memory of his wife and fellow benefactor. He adds that "the real St. Ann or St. Anne was the mother of the Virgin Mary and Jesus' grandmother and that there are many churches and shrines throughout the world that are named for her." In his description of Ann Suydam and her good works for the church, Stevenson finishes by saying, "If St. Ann's can be said to have a 'patron saint' it has a good one in the person of 'St. Ann' Suydam."

In 1875, Reverend Prescott also led the organization of St. Ann's Cemetery (established in 1876, according to Stevenson) and the construction of the parish rectory in 1879. West Sayville summer resident and wealthy New York City–based leather merchant Israel Corse provided the financing for the rectory.

In 1880, Reverend Prescott's St. Ann's Church also brought the Sayville community its first library at a reported cost of $1,000. According to Mr. Stevenson, in the *History of Suffolk County—1683–1882*, "St. Ann's Guild and Sayville library under the auspices of St. Ann's Church, though undenominational in its character, was organized in 1880. Its object was to furnish healthful, attractive and profitable entertainment for the young men of the village and thus draw them away or prevent them from falling into evil associations." The somewhat amusing passage goes on to say that the reading room was furnished with magazines and periodicals of various kinds and with nine hundred volumes of books, and that the guild has sixty-five members. The St. Ann's Parish *100th Anniversary Journal* says the reading room "was established over the store of Willett Green and Son." Also according to the *Anniversary Journal*, the library closed in 1886 because "support for the library was withdrawn" due to the financial strain on the parish. A public library would not return to Sayville for decades. Finally, in 1914, the Sayville Library opened its doors for the first time in space over Otto's Meat Market located on South Main Street.

In 1887–88 came the building of the crown jewel of the parish, the beautiful stone church. Stevenson described how the wealthy Walter

Lispenard Suydam (1854–1930) and his sister, Mrs. Robert Fulton Cutting (Helen Suydam) (1858–1919), provided the bulk of the funding for the new stone church. The two contributed between $25,000 and $30,000, a considerable sum of money in those days, toward its construction. The Suydams had decided to donate almost the entire cost of the church as a memorial to their parents, Charles and Ann White Schermerhorn Suydam, and to their deceased siblings.

In his book, Stevenson traces a great deal of St. Ann's parishioner genealogy. The Walter L. Suydam entry is of particular interest in demonstrating the wealth, and the connections to great wealth, of some of St. Ann's parishioners.

Stevenson points out that Walter L. Suydam's mother, Ann White Schermerhorn Suydam, was the sister of Caroline Webster Schermerhorn (1830–1908). In 1854, Caroline Schermerhorn married William Backhouse Astor Jr., heir to the fortune of John Jacob Astor. By 1863, William and Caroline Astor had built a large, luxurious town house at 350 Fifth Avenue, the present site of the Empire State Building. By 1872, Walter Suydam's Aunt Caroline had become the queen of New York and Newport society and, by 1887, thanks to the media of the day, had become known to all as "The Mrs. Astor."

During her reign as queen of society, Walter L. Suydam's Aunt Caroline Astor created an informal club of the social elite known as the "Four Hundred," reportedly reflecting the number of people of privilege who would fit in her ballroom. Her nephew, the St. Ann's benefactor Walter L. Suydam and his wife, Jane, were regular members of Aunt Caroline's Four Hundred, participating in her dinners, parties and the like.

Another Reverend John Prescott contributor and St. Ann's parishioner of some wealth and social prominence was Robert Fulton Cutting, the brother of William Bayard Cutting, who in 1882 bought a 642-acre estate in Great River. Utilizing plans conceived by the landscape architectural firm of Frederick Law Olmsted, the arboretum's development began in 1887. Mr. Olmsted is better known as one of the primary designers of Manhattan's Central Park. Today we know Mr. Cutting's estate as the Bayard Cutting Arboretum, one of the most beautiful of New York State's parks.

Any list of prominent contributors to Reverend Prescott and his St. Ann's Church must include the president of the Singer Sewing Machine Company and West Sayville/Oakdale resident Commodore Frederick Gilbert Bourne (1851–March 9, 1919). Bourne came by the title of commodore in 1902, when he was named to the position by the prestigious New York Yacht Club.

In 1888, Bourne became president of the Singer Sewing Machine Company and was well on his way to becoming a fabulously wealthy man. In 1889, he began buying up property in West Sayville and Oakdale and by 1897 had completed his Oakdale mansion. The house measured 300 feet long by 125 feet deep, with 150 rooms. It came with a roller-skating rink, swimming pool, bowling alley and a $20,000 organ. As with his friends the Cuttings, he, too, got Frederick Law Olmsted to design the beautiful grounds. Bourne named his cottage Indian Neck Hall after the creek running through the property. In May 1926, the Brothers of Christian Schools (a Roman Catholic teaching order) purchased the mansion for about $500,000 and established it as La Salle Military Academy. Today we know the property as St. John's University.

Frequent guests of Mr. and Mrs. Bourne at Indian Neck Hall included the Ludlows, the Bayard Cuttings, the Roosevelts, the Morgans, the Astors, Admiral Dewey and other assorted friends. Lost in Bourne's celebrity guest list was also St. Ann's Reverend John Henry Prescott. A few *Suffolk County News* articles following Bourne's death indicate his relationship with Reverend Prescott and St. Ann's Church. One of those articles says that upon his death, Bourne left $15,000 to the Church Charity Foundation, $10,000 to St. Ann's Church and $1,000 to Reverend John H. Prescott.

Another organization besides St. Ann's that brought together the locally civic minded—from the not so wealthy to the filthy rich—was the Sayville Fire Department. On August 12, 1878, the following charter members organized the Sayville Hook and Ladder Company:

Reverend John Prescott
Walter L. Suydam
Charles Edward Gillette
Isaac H. Green Jr. (architect for St. Ann's Church and the great-grandson of Sayville founder Willett Green)
Andrew Foster
F.W. Munkelwitz
James Nohowec

While Commodore Bourne may not have been a charter member of the Hook and Ladder Company, a *Suffolk County News* article from July 9, 1892, mentions that fellow Sayville firefighters had honored Mr. Frederick Bourne, a member of the Sayville Hook and Ladder Co., with a surprise party at his home.

The Cottages of St. Ann's

Finally, the list of Reverend Prescott's outstanding congregants includes a young and wealthy female parishioner by the name of Edith Corse Evans, granddaughter of the wealthy Manhattan-based leather merchant Israel Corse. In the early 1880s, Israel Corse owned a large summer home on the northeast corner of Montauk Highway and Rollstone Avenue in West Sayville. The Corse home, purchased in 1885 by Commodore Bourne and later destroyed, may have been constructed from timbers originally belonging to an old inn that became the subject of local legend as the Widow Molly Inn. In any case, Corse's granddaughter, Edith Corse Evans, loved visiting Sayville and Reverend Prescott's St. Ann's Church.

Since December 1912, St. Ann's worshippers have been reminded of Edith Corse Evans by a large, white Italian marble plaque posted on the eastern wall of the nave of the church. Written on the plaque are these few words surrounded by garlands of gray marble carved roses:

To the Memory of
Edith Corse Evans
Born in New York
September 21, 1875
Lost at Sea
On the SS Titanic
April 15, 1912

What the plaque does not tell is the story of the extraordinary heroism displayed by this thirty-six-year-old woman facing death aboard the mortally wounded *Titanic*. While there exist numerous variations of what transpired in the early hours of April 15, 1912, most seem to agree that the following is the version most closely mirroring what actually took place.

After all of the main lifeboats had been lowered, Colonel Archibald Gracie approached the *Titanic*'s second officer, who was shepherding women and children into lifeboat D. Colonel Gracie got Mrs. John Murray Brown and Miss Edith Evans as close to the lifeboat as he could before being stopped by a cordon the second officer had set up to prevent a rush on the boat. With space for only one additional passenger aboard the lifeboat, Evans turned to Brown and said, "You go first, you have children waiting at home." Brown took her place in the boat, which was then lowered away. It was the last boat to be launched, leaving Edith Evans to go down with the ship.

As Stevenson points out, the remarkable Reverend Prescott managed to get many congregants to contribute to projects that made the inside of

St. Ann's Church as beautiful as the outside. The Roosevelts—who are addressed in more detail in the following chapter—the Gillettes, the Corse family and others donated the following: the exquisite Tiffany stained-glass windows, apparently, but not definitively, a gift of the Cuttings; the solid polished brass lectern, a gift from Mrs. Alfred Fraser; the altar cross and vases from the Roosevelts; a sterling silver plate, a gift of G.I. Herbert and B.B. Schneider; the organ provided by Lena Evans and Edith Corse Evans, Israel Corse's daughter and granddaughter, respectively; the baptismal font from the Gillettes; and the silver Communion service from the John Wood family. Others also contributed money and expensive items that still grace the inside of the lovely old church.

Certainly we have ample proof of the unusually strong spirit of charitable giving and civic responsibility that lived within these early St. Ann's congregants. We might also argue that this spirit, ably encouraged by Reverend Douglas and then by Reverend Prescott, played a significant role in the Church Charity Foundation deciding to build its Cottages project across the street from St. Ann's.

Stevenson quotes a moving tribute written by Simon W. Cooper in the *Brooklyn Daily Eagle* following Prescott's death in January 1923 that seems to capture the essence of the man. In part, the piece says:

The Reverend Mr. Prescott was the ideal country rector, sound in his theology, devoted to his parochial work and one who delighted in doing good. He was a jovial man, yet never lost his dignity. No man was ever more faithful to the people committed to his care; nor had the church a more loyal exponent of its creed…He was a welcome guest at the mansions of the rich and in the humble homes of the poor. Wherever he went he radiated kindness and good will…It was given to few men to be better loved than was he; to fewer still to serve a parish for almost half a century. He leaves an imperishable record of loyalty to his God, his Church and to his fellow men.

THE ROOSEVELTS

The Roosevelt family relationship with St. Ann's Church began in the same year that Reverend Prescott came to Sayville. In 1873, Robert Barnwell Roosevelt Sr. (1829–1906), a two-term congressman from New York City and Teddy Roosevelt's father's brother, purchased two hundred acres of land between Bayport and Sayville. While the Roosevelts spent most of the year at their home in New York City, like many wealthy New Yorkers, they enjoyed summering on Long Island's South Shore.

Robert Roosevelt Sr. and his wife, Elizabeth Thorn Ellis (Lizzie), had two sons: John Ellis Roosevelt (Jack), born in 1853, and Robert Barnwell Roosevelt Jr. (Bert), born in 1866. Both John and Bert loved coming to Sayville and, like their father, were active in St. Ann's Church. They were contemporaries of Ida Gillette, who was also a St. Ann's regular. John was a member of the vestry in the early 1880s, and Bert served as the junior warden for a total of eight years between 1908 and 1921. Bert is said to have enjoyed a particularly close friendship with the parish rector, the Reverend Mr. Prescott.

In addition to supporting St. Ann's and the work of the church, these early parishioners also believed strongly in civic responsibility as well as national service. The following helps to illustrate their belief in giving to both church and state.

In April 1917, with the outbreak of World War I, a number of men from the Sayville and Bayport communities volunteered for local service against the threat posed by the German Imperial Navy. They formed United States Naval Reserve Force (USNRF) Section Base No. 5 in West Sayville. The Section Base became part of the Third Naval District headquartered in New York City.

Selected to command the Section Base was Lieutenant Robert B. Roosevelt Jr., USNRF. Lieutenant Roosevelt had the necessary credentials for such a command; he was well educated, a longtime Sayville resident and an avid and experienced local mariner. Being the son of the uncle of the twenty-sixth president of the United States surely helped as well. Another local resident and experienced Great South Bay sailor, thirty-three-year-old Ensign Walter L. Suydam Jr., USNRF, became his executive officer or next in command.

Besides being a skilled mariner, Ensign Suydam had another much-needed asset. Like Lieutenant Roosevelt, he came with his own boat. On May 25, 1917, the U.S. Navy, under what was known as a free lease agreement, acquired Suydam's yacht, the *Nemesis*. On June 7, 1917, after outfitting the sloop-rigged craft with a single machine gun and a coat of dark gray paint, the U.S. Navy placed the 42-foot-long wooden boat officially in service. The *Nemesis* became SP-343 (Section Patrol 343). The Naval Historical Center reports that Patchogue boat builder Gil Smith built the *Nemesis* in Patchogue in 1896. It displaced ten tons, drew 2.5 feet of water and cruised at just under seven knots.

Ensign Suydam and the *Nemesis* made their first patrol of the Fire Island Inlet within days after Congress declared war on Germany on April 6, 1917. The boat's mission was to prevent the running of supplies to German submarines, general observation and police duty, in addition to assisting the Naval Aviation Forces from the U.S. Naval Air Station in Bay Shore and the Coast Guard.

In early 1918, the men were put to their first real test when a German submarine laid a string of moored contact mines not far from the Fire Island Lightship (LV-68). At the time, the lightship was anchored only about nine miles south of Fire Island and forty miles east of New York Harbor.

According to the War Record of the Town of Islip, Suydam and Section Base 5 spent almost two weeks engaged in assisting U.S. Navy minesweepers and elements of the U.S. Coast Guard in clearing, dissecting and destroying these sensitive and efficient killing machines. Nothing to trifle with, each German contact mine, known as a Hertz horn mine, could carry a charge of hundreds of pounds of TNT.

According to the Town of Islip account, the U.S. Navy minesweepers broke the mines free of their mooring cables while Section Base 5 and the Coast Guard took on the very delicate task of capturing the mines and bringing each of them up on different parts of the barrier beach. Once on the beach, Suydam and at least one machinist's mate assisted two experts from the

U.S. Navy Mine Sweeping Division in taking the mines apart to study the advanced German design. The technical intelligence they gathered must have greatly assisted the U.S. Navy in improving the allied forces' future mine warfare capabilities. Finally, they burned out the hundreds of pounds of TNT from each mine, doing so without injury.

The Section Base also performed other significant acts, including helping to rescue a large number of officers and men from the cruiser USS *San Diego*, which sank 13.5 miles south of the Fire Island Inlet on July 18, 1918. Surely, these men set an example for others in the community, and in the local Episcopal Church, for years to come.

One note about the Roosevelt family's Episcopal faith: until the 1880s, future president Teddy Roosevelt maintained his family's original religion as Dutch Reformed. Dutch settlers in America in colonial times—when the Roosevelt family arrived in the United States from the Netherlands—founded the Dutch Reformed Church. Teddy Roosevelt's second wife, Edith Kermit Roosevelt, was a devout Episcopalian, and reportedly after the marriage in 1886 he often followed her to church. Beginning in the late 1880s, Teddy and the extended Roosevelt family of Sagamore Hill attended the Episcopal Christ Church in Oyster Bay, where the twenty-sixth president worshipped until his death in 1919.

In 1890, John Ellis Roosevelt, first cousin of U.S. President Theodore "Teddy" Roosevelt, commissioned Sayville architect Isaac Greene Jr. to create his summer "cottage" known as Meadow Croft. The lovely building, with a splendid view of the Isaac Greene–designed St. Ann's Church, was finished in 1891.

Beyond the marsh grass, atop a hill, stately Meadow Croft stood almost directly across the street from the Church Charity Foundation Children's Cottages. Harry Havemayer wrote in *East on the Great South Bay, Sayville and Bayport 1860–1960*, "[Meadow Croft] is one of the last remaining examples in the area of the elegant summer 'cottages' of the affluent in the Gilded Age." Now it might be said that the Church Charity Foundation cottages are two of the last remaining examples of the practical year-round "cottages" for the needy children of the orphan train era.

The foregoing provides something of a perspective on the activities, people and thinking behind the establishment of the Cottages. The Church Charity Foundation's project was born not so much out of the need to care for what we think of today as orphans but from a tradition of broader concern for the general well-being of all children who could not be cared for adequately. A *Suffolk County News* article from the summer of 1943 says: "While it has been

assumed by many that this institution was an orphanage, as an actual fact there is but one of the thirty residents who has no parents living."

In fact, prior to 1943, the number of orphans at the Cottages had been higher—there were the four Whitehouse children and others. Also, few if any of the institutions commonly referred to as orphanages in the late nineteenth and early twentieth centuries in America housed only children without living parents. Most facilities were home to children whose parents could not care for them due to ill health, a lack of money or other such serious problems. None of the government social safety nets we have in place today existed back then.

THE COTTAGES
BECOME A HOME

Mrs. Mary McEnnery Erhard, widow of an Episcopal minister missionary and mother of three grown children, two girls and a boy, served as the Cottages superintendent from 1930 to 1935. Erhard provided her thoughts about the nature of the facility in December 1933 when she wrote the following in her monthly column for the CCF's monthly newsletter the *Helping Hand*:

> *Home—Webster's Unabridged defines it as "One's own dwelling place. The house in which one lives." That exactly covers what the Children's Cottages are to our children. So we train them to speak of the place. It is the place where they actually live, where they are housed, fed, clothed, nursed in most illnesses, trained in work, taught their religion—to pray, to live highly and well—yes, where they are also loved and treated as the children of the house—a place whose very name shows it is theirs—that place is entitled to be called their home. We do not call it The Home—there is something faintly obnoxious about that—just plain home. And so it is.*

Today, the two primary buildings that made up the CCF Children's Cottages remain much as they were almost three quarters of a century ago. Betty Whitehouse, who visited there quite often in the late 1930s when she was dating John, described the facilities as comfortable and pleasant, with everyone careful never to refer to the facility as an orphanage.

Betty Whitehouse's comment that no one ever referred to the Cottages as an orphanage was not idly made. She and her friend, another longtime Sayville citizen, Ruth Travis, quite vehemently reject anyone's reference to

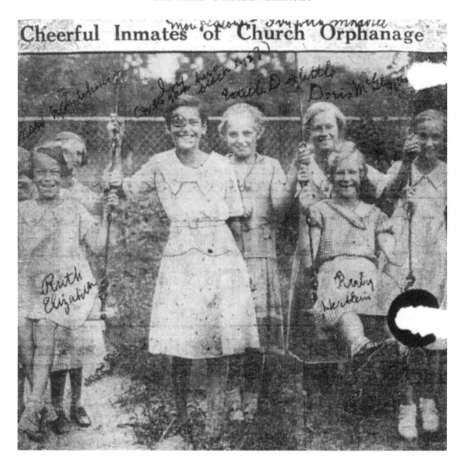

This photo from an unidentified newspaper was taken in the summer of 1932 behind the Cottages. Identifiable, *from left*, are Mary Whitehouse, Elizabeth (last name unknown), Ruth Coysh, Ivia (Ivy) Achino, Estelle Dolittle, Doris McGlynn and Ruby Hertlein. The identity of the last girl is unknown. *Courtesy of the Sayville Historical Society.*

the place as anything other than a home. Betty adds that many years ago, her eventual husband John told her she was never to refer to the Cottages as an orphanage. Betty also said that John remained reticent all his life to discuss having been brought up there. The reason for his reticence seems clear. Even today, when a local citizen who attended Sayville schools with children from the Cottages is asked about the facility, the person usually comments to the effect that they knew some of the "Cottages kids" and never had a problem with any of them. The comment seems to reflect a certain perception, perhaps unintended, that somehow Cottages kids were different, maybe even inferior to other children.

Eunice McGlynn, now Mickey Walker, who was also an orphan and grew up in the Cottages, shed some light on the Cottages' children's special sensitivity to the words "orphan" and "orphanage." In 2007, she related the story that one day a schoolmate derisively called her an orphan. She responded to her tormentor that at least her father wasn't a "stinky garbage man," or words to that effect. The other child reported her comment to her parents, who then complained to the Cottages' superintendent. The Cottages' superintendent called in the young Miss McGlynn and chastised her for her behavior toward the other child. Mickey Walker said it was the only time anyone ever called her an orphan.

Nowadays we salute the courage of people who overcome the challenges of being an orphan and succeed in life anyway. But people in the 1930s and 1940s seem to have viewed orphans as something less than first-class citizens, perhaps because of the legacy of the roving bands of criminal orphans so prevalent in New York City and other big cities from the 1850s until well into the early 1900s. For John, Mickey, Betty, Ruth and others who lived through the period of the Cottages, living in an orphanage apparently could label a person as socially inferior.

As noted earlier, a number of the inmates had one parent, and some even had both parents who did not have enough money to raise their children. Many of the parents could not even afford to make the trip to visit their children on a regular basis. Mary Erhard describes this fact of life at the Cottages, and the inmates' reaction to it, in several places in her scrapbook/diary made up from excerpts from the *Helping Hand*: "Sometimes I wonder if there are not friends who would like to invite away, if only for one week, some boy or girl who has no relatives to ask them. Some of the children never spend a night away from here—save if they need hospital care."

It seems quite remarkable from our modern perspective that Cottages children did so exceedingly well in life when they suffered such apparent hardship as children. Mickey Walker described how they occasionally had to confront hurtful social derision from schoolmates and other children born to more fortunate circumstances. They did not have the benefit of the immediate availability of a parent to intercede, without hesitation, on their behalf. The fact that virtually every one of the Cottages children would succeed in life—and some achieve significantly—speaks to the exceptional character of both the children and their caregivers.

WHO WERE THE INMATES?

C onsider the times when the four Whitehouse children were transitioning to life as orphans at the Cottages. In Europe came the rise of Nazism, Fascism and Stalinism, at least in part in response to economic hard times. In the United States, the Roaring Twenties were over, the new Ku Klux Klan was losing membership, the lucrative if not dangerous rumrunning trade was soon to become a thing of the past and for everyone the stock market crash of October 1929 was heralding a new era of hardship that would become known as the Great Depression.

In late 1929, life suddenly became much more difficult. The bread lines in New York City fed thousands of people who only a few years earlier had been gainfully employed. For the four young Whitehouse children, the loss of two loving parents, followed by the trauma of moving to a distant home for children, made the beginning of the Great Depression an especially difficult time. In John's case, in a matter of three years—from the age of five to the age of eight—he went from life at home in the Whitehouse Hotel with a loving mother and father to life as an orphan. Hank, the oldest child, clearly felt responsibility for the others and carried with him the pain of the memory of his father's death in his own arms. The men and women who managed the Children's Cottages in Sayville must have understood what a huge challenge it would be for them to make these emotionally battered children feel loved, safe and at home.

Another child Mary Erhard mentions in her writings is Lillian Maddare. Mary wrote that this "fair-haired and frail" little girl had lived in poverty with her ailing grandmother. Early one evening the grandmother died, leaving the little girl to spend the night with the body. She apparently arrived at the Cottages the next day.

The Cottages of St. Ann's

In a November 1934 piece for the *Helping Hand*, Mary Erhard discusses how she, and presumably the Church Charity Foundation as a whole, saw the mission of the Children's Cottages. She wrote:

> *This home has always since its inception been a "religious house," though not, of course, in the formal sense of a convent. It is felt that the formal training of the children to high ideals, and the development of a sturdy Christian character is by far the most important task before us; that to bring up and turn out merely healthy and intelligent, young animals would be a waste of our lives and the Church's money. How far we succeed time alone can tell; and even then due credit, in the best cases, must always be given to the original heredity and earliest training, which of course preceded our influence. But we have a large task also.*

In the course of her five years of contributions to the Church Charity Foundation's monthly newsletter, Erhard includes several passages on her observations about the character of the Cottages' children. In a September 1933 piece she wrote: "It is very delightful to witness the fatherly attitude of our boys towards a new little boy. Perhaps there are some who have dealt with boys who will not believe this, but I can state it is the truth here. The main trouble is to see that the newcomers are not spoilt or treated as toys."

In her May 1933 column, she described the arrival of two new inmates: "Our numbers have been augmented by the accession of Clifford de Bruhl and Ann Doyle, both five. I sometimes wonder…why it is that I always seem to have such attractive children sent to me here. And usually such good ones, too."

In the margin of her notebook, next to the above passage, Erhard penned a touching note: "[The first thing five-year-old Ann told me on arrival was] I make my own bed and I am not a baby." Seems there was not great opportunity for being a baby back then, even for a five-year-old girl.

No direct testimony exists about how Hank, John, Gil and Mary reacted to their initial placement into Mrs. Erhard's care, but in the margins of her June 1933 contribution to the *Helping Hand* Erhard wrote the following: "I had the four, Henry (Harry), John, Gilbert, Mary—entire orphans of good parents, early lost, by illness and death. All bright, all with consciences."

Hank was called "Harry" because when he got to the Cottages there was already one inmate named Henry, and two Henrys would have been confusing. Still, being renamed in that way at the age of ten must have had something of a deflating effect on a child's developing ego. Similarly, children did not have their own birthday celebration; rather, one day a month was

used to celebrate the birthdays of all the children born in that month. The special treat for birthday celebrants was not a present or a cake but a dish of ice cream.

A theme running through Mary Erhard's writings is her constant concern with the health of the children. She registers particular concern with the flu and decides on the frequent application of cod liver oil as the best medicine for warding it off. In early 1934 she wrote in her column for the *Helping Hand*: "We seem to be developing at last that elusive but needed quality, 'resistance.' In part this is doubtless due to the cod-liver oil absorbed quite regularly, and more or less cheerfully, by many of our number, to the amusement of some of the parents."

She also penned in the margins next to this piece, "I gave it to the ones with colds and those who looked peaked. Ed Ackerly loved it! John Whitehouse hated it." Of course, Mary Erhard had a right to be worried about the flu: it had not been many years since the Spanish flu epidemic of 1918–19 killed millions of people worldwide.

Mary Erhard also worried about the psychological well-being of the children in her charge. In December 1932, in her column for the *Helping Hand*, she wrote about her concern for how the children would function outside the cloistered environment of the Cottages:

> *I always rejoice when our children can take care of themselves away from home, and try to give them the opportunity while in our care to learn what escalators, elevators, subways, etc., really are. Only a few months ago a welfare worker was telling me of a boy of sixteen who was afraid to enter a trolley car. Our small number of children can be taken about more and familiarized with the paraphernalia of modern city life, lest they emerge from Sayville young Rip Van Winkles.*

In fact, Mary used money given by benefactors as entertainment money to take the older children to New York City. She mentions visits to the Cathedral of St. John the Divine, the Metropolitan Museum of Art, the American Museum of Natural History and productions of Shakespearian plays—in 1933 the girls went to see *Macbeth* and the boys *The Taming of the Shrew*.

And speaking of the psychological well-being of the children, Mickey Walker said that corporal punishment for wrongdoing was not something prohibited at the Cottages. While Mickey did not say what she had done to warrant a spanking, she did indicate that she was proud of the fact that she had only been spanked once!

FATHER DIVINE'S
COTTAGE ANGELS

A t one point in the early 1930s the Cottages inmate population reached forty-three, with two or three housemothers, two cooks and two handymen, plus the occasional visitors. Who cooked for all those children and their caregivers? During part of the first decade of the Cottages, two African American women from Father Divine's Peace Mission at 72 Macon Street—now Macon Avenue—in Sayville did all the cooking.

Mary Davis cooked for the boys and Kamartha Grace for the girls, but both women were well known to all the children. Usually the food they prepared was the standard domestic fare of the time, including chicken, hamburgers, cereal and the like. In 1933, Mary Erhard wrote for the *Helping Hand*:

> *We are very proud of our new cereal which is made by buying whole wheat at one and a half cents a pound and grinding it in a coffee mill, the result being a porridge not only crowded with vitamins, but also more tasty than almost any packaged cereal, so goodbye to these. We are going to try oats from the feed store next…in these times the paring of the budget assumes a paramount importance.*

On frequent occasions, particularly in the warmer months, the cooks would be called upon to prepare clams, crabs and all manner of fish, from small blue fish—"snappers"—to eels and even the occasional fifty-pound "torp," or American snapping turtle, as it is officially known. The word "torp" for these ponderous swamp creatures derives from the Virginia colonists' abbreviated version of the original Algonquian word "torope."

The 1930 Islip town census showing the Cottages population.

In the May 1930 Islip Town Census for the Cottages, cook Mary Davis said she was born in Massachusetts in 1865. Unfortunately, little more is known about her. As with almost all of Father Divine's followers, she would not reveal the events of her life prior to joining the father's flock. We know the children at the Cottages liked and accepted her, the older ones recognizing she had a world of experience behind her, but knowing none of the details.

Probably for a combination of personal, religious and financial reasons, Mary Davis, in her mid-fifties, decided to seek a new start in life. She may have heard about Father Divine's ministry by word of mouth or attended one of his services in Brooklyn or elsewhere. Whatever her inspiration, in the 1920s Mary came to Sayville to be a part of the father's flock.

The Cottages of St. Ann's

In the early 1920s, Reverend Major Jealous Divine—Father Divine to his followers—called for achieving success through hard work, abstaining from sex, eschewing alcohol, drugs and other harmful products and vices and worshipping God. Adherents had to sever all family ties and dedicate themselves to Father Divine's religion. Mary Davis, like many other blacks and some whites in his group, welcomed the opportunities his ministry afforded. For those willing to follow his strictures, Father Divine's ministry provided them with job prospects, housing, food, clothing and, perhaps more importantly, knowledge that God loved everyone equally, regardless of race or gender.

Mary Davis, who was sixty-five years old in 1930, often spoke with the young white boys who were the beneficiaries of her talents in the kitchen. She was almost a half-century older than they were, but there existed a kinship of spirit between Mary and those young boys, especially the ones like Hank, John and Gil who were without a mother or grandmother.

For the first part of her life, Mary Davis probably led a hardscrabble existence with few, if any, opportunities. Father Divine gave her the opportunity for something better; she probably wanted the same for the boys for whom she worked. Like her, these youngsters had few worldly possessions and little if any family life. The boys found her to be comforting and understanding, rarely passing judgment and always ready with a word or act of personal encouragement. Mary Davis became a kind of *de facto* grandmother.

Mary sometimes shared with Hank her thoughts about what the future might bring and how he would be there to be a part of it. On one occasion Mary told him, "Just you wait, Harry, and one day you'll see trains in the sky! You'll understand when you see it!" Whether Mary Davis was simply predicting progress in the field of general aviation or something else, we'll never know. Certainly some of the jumbo aircraft we have today might qualify as "trains in the sky." But the important thing is that she enjoyed Hank's confidence and could speak inspiringly to him.

The other influential African American in the children's lives was a younger woman named Kamartha Grace. According to the 1930 Islip Town Census for the Cottages, Kamartha Grace, who cooked for the Cottage girls, said she was born in Maryland in 1890. She was in her late thirties when she followed Father Divine to Sayville to be part of his Peace Mission. It is possible she was familiar with Divine before he arrived in Brooklyn in about 1917.

Coming from Maryland, Kamartha Grace would have known the Jim Crow laws and the parallel social worlds of black and white. She heard Divine exalt the individual worth of all people, regardless of race or station in life, and she embraced Divine's overall message of positive and practical

religion. His message made sense and was not difficult to follow—work hard, save your money, respect yourself as well as others, worship God and you will be rewarded. To Kamartha Grace, Divine's promise of reward for such behavior and lifestyle undoubtedly made good sense.

Particularly for John, Kamartha Grace possessed useful and fascinating abilities beyond knowing how to cook. Being poor and from rural Maryland, she knew about wildlife. She knew about the haunts and habits of animals, how they behaved, how to catch them and what to do with them when you did.

In the summer months of 1930, 1931 and 1932, John and some of the other boys of that age spent time in what is today the Sans Souci Nature Preserve. Sometimes the boys went exploring in an old flat-bottomed rowboat donated to the Cottages by some thoughtful person who knew just how valuable a boat could be to young boys. They rowed, and when they couldn't row anymore they poled slowly up the long, northernmost stretches of Brown's River, past Meadow Croft, up to the Long Island Rail Road tracks and beyond. The boys mostly traveled the primary stream that hooks to the right after passing under what is now called Bryan's Bridge. The waterway becomes narrow, no more than six to eight feet wide in some places, with eight- to ten-foot reeds and cattails running straight to the edge of the water, literally towering above the stream's surface, almost completely hiding the rest of the world from view.

Freshwater fish and turtles proliferated. Sometimes the boys saw raccoon and muskrat and, on rare occasions, red fox. Larger birds were plentiful, including the beautiful mute swan, osprey, red-tailed hawks and heron. But for color, nothing beat the wood ducks, redwing blackbirds, stubby little kingfishers and other birds. The crystal clear water, in many places four to five feet deep, allowed the boys to see clear to the bottom. Even the big torps, enjoying the camouflage provided by the deep mud, could not escape observation.

Kamartha Grace knew about these swamp and woodland creatures and enjoyed imparting her knowledge to the younger boys, who loved listening to her. They asked Kamartha about the birds and animals they saw, their habitats and behaviors.

In her column for the *Helping Hand*, Mary Erhard gives credit in several places to John for his skills at hunting big snapping turtles and making them ready for the Cottage's stew pot. She wrote:

> *Our diet has also been varied by turtle soup, provided by the exertions of one of our boys (John), who killed and cleaned the "torp" after catching it—the largest I have ever seen, though they claim a larger one was caught last summer when they did not know turtles were edible. As the turtles bite*

the feet of unwary swimmers, a large one caught and made into soup is so to speak twice blessed—it blesses them who eat it and them who are not bitten.

And in the August 1931 column she writes, "Last month I told about the 'Torp.' We have since eaten another one, cleaned and cut up (and very neatly) by the same eleven-year-old hands (John)."

Kamartha had taught John that a torp out of the water is notoriously aggressive, with long sharp claws on webbed feet and a vice-like bite that can easily remove a finger or two. Out of water a torp can move quickly in any direction and even flip over within seconds when placed on its back.

While we do not have the details of the boys' first great torp hunt, we do know the results. We also know that Kamartha Grace was both surprised and pleased with the boys' success. Patiently she showed them how to finish the hunting job they had started.

She began by instructing them in the finer points of the cleaning process, allowing them to do it for themselves so they might learn firsthand the work involved. First she had them hang the carcass from a stout tree limb for about a half hour to drain the blood. Then they placed the carcass on its back and, using a sharp knife, cut between the bottom and top shells, lifting off the bottom one. The boys must have been fascinated and full of questions about the turtle's body parts and how they functioned. The shell became a greatly desired treasure that the boys decided would look perfect as a wall decoration on the garage behind the girls' cottage. Maybe the girls found the idea somewhat less enthralling, because there is no record of the shell remaining in place.

Next, Kamartha had John and the boys remove the entrails out of the top shell and skin the legs, neck and tail, removing any extra fat attached to the meat. Finally, she directed him to cut up the meat and place it in a bucket of cold water. From here she took over, loading the fresh meat into a stew pot to boil and adding vegetables and other ingredients that would make the torp table ready.

So it was that John and some of the other boys learned about the fish, birds and animals that lived in the river, swamp and surrounding woods. More torp hunts followed, with other hunting and fishing trips resulting in more food for the Cottages.

Just as Mary Davis gave Hank the opportunity to consider big ideas, Kamartha Grace gave his younger brother the practical gift of knowing how to hunt, fish and prepare the catch. What both women taught their young charges would be remembered and used throughout their lifetimes.

FATHER DIVINE
AND THE KKK

Just who was Father Divine? Most researchers agree that sometime not long after the Civil War, the highly charismatic Father Divine was probably born George Baker, the son of former slaves, somewhere in the South. In official documents, Father Divine gave at least three different dates of birth—1877, 1883 and 1885—and a variety of places of birth, including Rhode Island, the Carolinas, Virginia and Georgia. Jill Watts, in her book *God, Harlem U.S.A. The Father Divine Story*, says that her research shows he was born in May 1879 in the home of Nancy and George Baker in Rockville, Maryland.

At an early age, George Baker became an itinerant evangelist traveling throughout the rural South. He preached the love of God and the need for a new social order of equality to replace the Jim Crow laws and social mores of southern society. His campaigns, with heavy emphasis on the God-given equality of the races, were not popular with authorities in the South; in fact, he was seen as a troublemaker and was arrested, imprisoned, charged a number of times with subversion and on one occasion even arrested for being a lunatic.

Sometime in the period of 1915–17, Mr. George Baker had tired of the South and decided to come north to New York City to preach his gospel. He found a suitable apartment in Brooklyn, just large enough to comfortably house him and his small group of followers. At first his followers called him Father Divine, but later he officially changed his name to Reverend Major Jealous Divine. He also laid down the tough moral strictures he expected members of his flock to follow. Everyone was required to abstain from sex, drugs, gambling, alcohol, smoking and profane language.

The Cottages of St. Ann's

Father Divine in an undated photo. *Courtesy of the Sayville Historical Society.*

Most texts say that Father Divine married for the first time in about 1919. He married one of his disciples, a woman reportedly older than himself, named Pinninah, who became known as Mother Divine. Information in the U.S. Census from 1930 reflects conflicting ages and dates. The 1930 census says Pinninah was born in 1880 in Maryland and Father Divine born in 1885 in Rhode Island. Father Divine's age at their marriage is given as twenty-two years and Pinninah's as twenty-seven, which, if correct, would put the date of their wedding at 1907, a dozen years earlier than the generally accepted date.

By 1919, wanting to shelter his wife and his following from the evils of the big city and to expand his ministry outside the New York metro area, Father Divine purchased a two-story house at 72 Macon Street in Sayville. The house, which still stands today and continues to function as a Peace Mission, is part of Father Divine's International Peace Mission Movement. The home is located just north of the Long Island Rail Road tracks and Montauk Highway on the east side of Sayville.

The 1930 Islip town census showing the population of 72 Macon Street at that time.

A variety of texts report that by the mid-1920s, Father Divine had about a dozen followers living with him at his Macon Street residence. Within a few more years many more people, including a number of whites, joined to make the residence a far more crowded communal dwelling. Interestingly, the official 1930 census for Macon Street does not reflect these numbers. It lists only sixteen "boarders" in addition to Father Divine and his wife, Pinninah. Of these sixteen boarders, ten are under the age of thirteen, with two of these under the age of two. Three of the six adult boarders are listed as of the white race; all the other boarders are listed as African American.

Hank said that although the 1930 census for the Cottages shows Father Divine's disciples Kamartha Grace and Mary Davis living at the Cottages, neither did. Hank was certain they lived with Father Divine on Macon Street. Thus, for the 1930 census it would seem that at least two of Father

Divine's disciples claimed to live with their employers instead of with Father Divine at the 72 Macon Street Peace Mission.

Most written and oral accounts say that in the early years of Father Divine's residence on Macon Street, the Sayville community accepted him and his followers as hardworking and decent people. However, as time went on, local residents, almost all middle-class whites imbued with the Protestant work ethic's emphasis on the appearance of frugality, voiced concern with Father Divine's penchant for carrying a large amount of cash in his pocket, appearing in public only in fine suits and driving a Cadillac. By the early 1930s, a number of village residents worried about the propriety of his increasingly large interracial commune. There were rumors that he maintained a harem in his Macon Street home and engaged in sexual orgies and escapades—none of which, of course, was true.

However, it is probably fair to say that many people in Sayville and the surrounding communities maintained an open mind toward Father Divine and his congregation throughout most of their tenure on Macon Street. Kamartha Grace and Mary Davis, two of Father Divine's flock, worked in close contact with more than forty youngsters living in the Cottages who were being strictly raised in the Episcopal faith. There seemed to be no concern from Mary Erhard, or any other member or associate of the Church Charity Foundation, about the religious beliefs or practices of these two employees.

Throughout the decade of the twenties, the Sayville community not only included Father Divine and his following but also, as discussed earlier, a significant and growing number of Ku Klux Klan members. Today many people have a visceral reaction when the Ku Klux Klan is even mentioned, with very few individuals—except perhaps historians—differentiating between the "old" Klan, the "new" Klan and the more recent KKK organizations, all of which have used the same name. In the 1920s, many Americans viewed the new KKK as a socially acceptable organization. The front page of *The Suffolk County News* of March 25, 1921, provides evidence of just that. In a story about the Sayville basketball team, the lead paragraph reads as follows:

> *With Guernsey, Babylon's fast forward missing, the visitors were an easy mark Saturday night, when before a big crowd in the Opera House Sayville defeated Babylon 57–27. There is but one more game this season. Tomorrow night there will be no game but next Saturday night, the 2nd of April, Sayville is to meet the Ku Klux Klan of East Moriches, for the season's final scrap on the court.*

A variety of sources reported that in November 1922, Clergyman Andrew E. Van Antwerpen of the First Reformed Church of West Sayville permitted a gowned and hooded Klansman to address his congregation. *The New York Times* of November 8, 1922, said the following:

> *Bearing out Dr. Haywood's (the Reverend Oscar F. "Big Bill" Haywood, a national KKK official) contention that there is much Klan activity in and near New York City, a dispatch from West Sayville, L.I. stated that the congregation of the First Reformed church in that village was addressed by a white robed and hooded Klansman on Sunday evening. A local branch (known as vigilance committees) of the Klan is believed to have been organized there.*

The KKK appears to have fully arrived in the area by the spring of 1923. The March 23, 1923 edition of *The Suffolk County News* reported the following:

> *The largest public gathering which Sayville has seen in many a day assembled in the Congregational Church last evening to hear an address on the objects, aims and principles of the Ku Klux Klan…The meeting opened with the singing of* America *accompanied by Samuel P. Greene the church organist. Prayer was offered by the Rev. A.E. Van Antwerpen, pastor of the First Reformed Church of West Sayville, which was followed by the singing of the Star Spangled Banner.*

The *News* pointed out that the (unnamed) pastor of the Sayville Congregational Church protested the rental of his church for the meeting and that it was the Congregational church "officials" who actually rented it out to the Klan.

The March 23 *Suffolk County News* front-page story continued:

> *Oscar Haywood of North Carolina, one of the big guns of the "Invisible Empire," spoke to a group that packed* [the church] *to the doors, with every available inch of standing room occupied in the main edifice. The partitions dividing it from the lecture room had been lowered and in that part of the building there were probably two hundred more, many of whom stood on chairs for an hour and a half in order to get an occasional glimpse of the speaker… Although Sayville and West Sayville people were largely represented, there were scores from Bay Shore, Islip, Patchogue and some from more distant points…* [the speaker] *received a respectful hearing and at times his points were loudly applauded—no masks nor gowns were in evidence.*

The Cottages of St. Ann's

The churches were not the only recruitment venue for the KKK. The April 13, 1923 edition of *The Suffolk County News* reported that on the evening of April 11 a crowd estimated at approximately one thousand attended a talk on the KKK given at Sayville's Cedarshore Hotel by the Reverend Mr. Moore, a Baptist clergyman. The article says that Mr. Moore began his talk by saying that he came to the Cedarshore meeting "upon the request of Sayville citizens and had been sent here from Atlanta."

Moore told the crowd, "The Klan stands for religious liberty, free press, free speech and the separation of Church and State." He declared that its tenets were based upon the principles upon which this country was founded, that it restricted members to Protestant gentile white Americans and already had a membership of nearly three million, with more than thirty thousand Protestant preachers enrolled. Moore also announced that the women's auxiliary of the Klan would be organizing on Long Island the following week.

Harry Havemeyer, in his book *East on the Great South Bay: Sayville and Bayport 1860–1960*, writes that in May 1925, the Sayville Methodist Church was filled to overflowing with an attendance of one thousand people as two hundred Klansmen wearing robes but not masks attended a Sunday evening service to listen to the pastor preach a sermon entitled "The Spirit of Universal Brotherhood."

Charles P. Dickerson briefly addressed the same May 1925 KKK meeting in *A History of the Sayville Community.* He wrote:

> *The Klan came to this area about 1922. A 15-foot cross was burned in the Village Square on Feb. 12th, 1923. In 1925 a public Klan meeting was held in the Methodist Church. Hundreds of local misfits and oddballs joined the organization and enjoyed the cross burning ceremonies. For $16.50 you could buy a nightgown and a dunce cap. Leading citizens and politicians who should have known better, kept their mouths shut, either from fear of harm or loss of votes.*

Dickerson is correct in his date for the local cross burning, but he is misleading in his description of the location and the number of crosses. According to an article on page one of the February 16, 1923 *Suffolk County News*, crosses of wood "12 or 15 feet" in height wrapped with a flammable material and soaked with an accelerant were lit on fire at eleven o'clock on Monday night, February 12. The cross in West Sayville "was set up in the field south of the main road [Montauk Highway] and east of Atlantic Street, not far from the truck house." In Sayville the cross was "propped up

and attached to the back fence" in the rear of a private home on Railroad Avenue. The Bayport cross was south of the main road (Montauk Highway) and a short distance west of the "brewery." In Blue Point, the cross was erected near Blue Point Avenue not far from the firehouse.

The *News* also reported that cross burnings took place simultaneously in 1923 in eight other Long Island towns. Reports of the incidents said that the Klansmen responsible for the burning crosses were seen "only in a few places and in only one instance, in Hempstead, were any men seen who were wearing the masks and robes of the order and in that case, they made a hasty departure in automobiles."

What seems truly remarkable is that for years before and after the 1923 cross burnings and the burgeoning local membership of the KKK, the Klan and Father Divine's following coexisted in Sayville with no known act of violence or even so much as a heated argument.

However, Mr. Havemeyer suggests that while everyone seemed to coexist in peace and harmony, tensions were steadily building. He wrote:

> In the summer of 1931 there occurred a large rally of Klansmen in Bayport on a field north of Montauk Highway. Some three to four thousand members from all over Long Island attended the event, which was marked by three hours of speeches, parades and finally at dusk the lighting of the cross. This rally could have been organized in reaction to unrest felt in the Sayville-Bayport community over the black cult that had developed in the 1920s at a house on Macon Street in Sayville.

However, by the summer of 1931, KKK rallies had been an ongoing phenomenon for the better part of a decade on Long Island. The Bayport rally, like the other Long Island KKK rallies of the time, may well have focused as much on the evils of rumrunners, Tammany Hall, foreign immigrants and people of the Jewish and Roman Catholic faith as it did African Americans or Father Divine and his following.

In the 1920s and early 1930s, on the South Shore of Long Island, the new KKK derived considerable political support for its attacks on those who trafficked in rum or any other related aspect of the thriving illegal trade in alcohol. Criminal activity directly related to rumrunning was rampant, including a significant number of murders. In 1919, for example, the soon-to-be infamous American gangster Al "Scarface" Capone stayed in Amityville while working for Frankie Yale as part of his notorious Five Points Gang. Capone, only a twenty-year-old thug in 1919, worked the local rumrunning

trade. He later went to Chicago at Yale's behest, and the rest, as they say, is history. *The Suffolk County News* recounted in its May 26, 1960 special edition: "In one summer month [during Prohibition] there were 13 homicides in Suffolk County, which was sometimes used as a terminus of the New York gangland 'ride.'" Responsible citizens of the day viewed the lawlessness as a serious problem in great need of a timely solution.

An article in *The New York Times* of December 21, 1921, also described the magnitude of the Prohibition problem on Long Island:

> *Not more than six or eight rum vessels are now outside the three-mile limit hoping to land their contraband at this port. Prohibition officials say their number was estimated at from 100 to 800 ten days ago. "Seven boats along the Long Island shore have kept away," according to John Appleby, Zone Chief for the states of New York and New Jersey. "To our knowledge not one boat got into the Great South Bay, a favorite place for rum-runners."*

The new KKK's positions strongly opposing the illegal traffickers and supporting strict obedience to the law won it many adherents, especially when responsible political and social organizations seemed to turn a blind eye to the problem of lawbreakers. The new KKK's law and order message helped it achieve a much broader public acceptance than it might otherwise have enjoyed.

Whatever the motivations of these local Klan members, the Cottages felt no effect of the unrest and tension. Hank, who was twelve years old in 1931 and knowledgeable of Father Divine's mission from Kamartha Grace and Mary Davis, said he was totally unaware of any KKK activity in Sayville. Hank knew about the KKK. He remembered his father talking at some length about a woman in Oceanside who lived about a block away as being in the Klan and what that meant. Similarly, Mary Erhard did not allude to the new Klan, hostility toward Father Divine's group or any local tension in any of her writings.

Jane S. Gombieski, in her article "Kleagles, Klokards, Kludds and Kluxers: The Klan in Suffolk County, 1915–1928" in *The Long Island Historical Journal*, offers one good reason why the Cottages, St. Ann's and the Church Charity Foundation escaped the evils of the new KKK. She writes: "The Right Reverend Frederick Burgess, the Bishop of the Protestant Episcopal Diocese of Long Island (the ultimate authority for the Church Charity Foundation) announced publicly in October 1923 that he would 'close any of his churches which tolerated the hooded patriots within its confines.'"

Neither the Klan nor Father Divine's mission was to last. The two groups abruptly dropped from sight at about the same time. The Klan was brought down by national-level scandals, federal investigation and a resultant disenchantment by the membership, the repeal of Prohibition and the financial burdens of the Great Depression, while Father Divine's departure came about for much different reasons. However, it is important to note that while Father Divine had moved out of Sayville by 1933, his Peace Mission remained at 72 Macon Street (now Avenue) and is still there today.

There exists no known direct evidence linking Father Divine's leaving Sayville with the significant local presence of the new Klan. But if the new Klan were not ultimately responsible for forcing Father Divine out of Sayville, who or what was? Perhaps it was, at least in part, Father Divine's own great successes.

A number of historians point to 1927 as the beginning of Father Divine's exodus from Sayville. They cite 1927 because that was the year he began his recruitment campaign to add more people to his flock. By 1928, some reports say he had as many as ninety skilled and unskilled workers living full time in his Macon Street house. (Remember, the 1930 U.S. Census listed only eighteen people, including Father Divine, his wife and ten children.) While it is impossible to say precisely how many more people joined Father Divine's flock in the early 1930s, almost certainly the numbers grew at the Macon Street residence. And while his Macon Street boarders remained law abiding and hardworking, a large number of people in one relatively small suburban house created some problems for a small-town neighborhood.

Father Divine's persona also began to change. In 1930, Father Divine, reborn for a third time, officially changed his name from Reverend Major Jealous Divine to Father Divine. It was also at this time that he began openly referring to himself as God.

By March 1931, Father Divine's Sayville residence had become a magnet on Sundays for thousands of people, primarily African Americans but also a fair number of whites, who came from as far as New York City for free food and to hear his loud, revivalist-style ministries. By September 1931, many people in the local community had grown concerned about the influx of the Sunday crowds and annoyed with the traffic and the noise coming from Macon Street. Longtime South Sayville resident Adrian (Al) Bergen recalled that on any given Sunday afternoon and evening, particularly with a north wind, the sounds from Macon Street could be heard quite clearly as far south as his residence at 16 Colton Avenue in South Sayville, more than one mile away.

The Cottages of St. Ann's

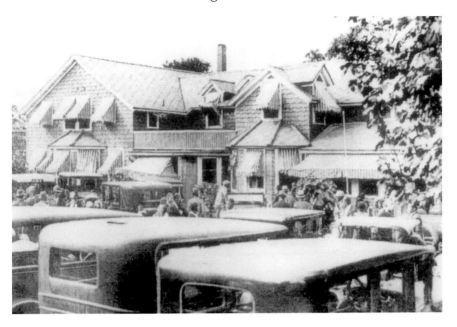

Father Divine's Macon Street residence in Sayville in the summer of 1931. *Courtesy of the Sayville Historical Society.*

By the fall of 1931, the pressure from the local citizenry on law enforcement to do something about the disturbance was becoming overwhelming. On the warm autumn day of Sunday, November 15, 1931, a particularly large group of followers visited Father Divine's Macon Street headquarters. Reports say that the worshippers danced, spoke in tongues and sang more loudly than ever. Some versions of the scene say that near midnight some of the worshippers had worked themselves into a frenzy. One witness reportedly said it was as if Father Divine were seeking to confront the law enforcement action he knew was bound to come.

Late in the evening of November 15, 1931, Suffolk County Assistant District Attorney Joseph Arata, accompanied by Sayville Police Officer Richard Tucker, four or five deputy sheriffs, six New York State troopers and a contingent of Sayville firemen with fire hoses at the ready, raided the Macon Street mission. Father Divine was arrested peacefully along with about eighty of his followers on a charge of disturbing the peace. They were put on buses and taken to the Sayville Courthouse building on Railroad Avenue for processing. About fifty-five of Father Divine's disciples paid the five-dollar fine for disturbing the peace, but more than twenty-five, including Father Divine, contested the charges and asked for a court date.

Meanwhile, the local community continued to seek a more lasting solution for the noise and congestion that the Peace Mission brought to the streets of the otherwise quiet hamlet of Sayville. On Saturday night, November 21, 1931, the citizens of the town got together in the Sayville High School auditorium to discuss the problem. A standing-room-only crowd estimated between seven hundred and one thousand turned out. Also in attendance were about forty members of the Peace Mission, including several of Divine's white followers.

Reports of the meeting indicate that while occasionally the discussion became heated, for the most part people remained calm and orderly, without resorting to name-calling or any hate speech. After much discussion, a number of Sayville property owners devised a plan to force Father Divine to move his Peace Mission to a more remote location if he still refused to do so voluntarily.

About six months after the November 21 town meeting, on May 24, 1932, Father Divine's trial on charges of disturbing the peace began in Nassau County's Mineola Court. On June 5, the jury found Father Divine guilty of being a public nuisance, and the presiding judge, Supreme Court Justice Lewis Smith, gave him the harshest possible sentence of one year in jail and a $500 fine. But only four days after passing sentence, Judge Smith, who had appeared to be the picture of good health, dropped dead. The death of the judge significantly enhanced Divine's reputation, at least among his followers, as "God," or at least the closest manifestation of God on earth.

In June 1932, Father Divine's sentence was overturned on appeal, and he was released from jail. But the incident caused him to decide not to establish any more "heavens" (buildings with followers of Father Divine's International Peace Mission Movement) in what he viewed as unfriendly white communities such as Sayville. Father Divine also decided to move out of his Sayville home and shift the center of his operation to Harlem. But he never forgot Sayville, saying until his death in 1965 that it was the best "heaven" he ever created.

Following his move in 1933, a number of Divine's followers remained in the Macon Street house and continued their local work. It is unclear whether Kamartha Grace, who had become such an integral part of the Cottages, returned with Divine to Harlem or simply left on her own. As noted, Mary Davis, at the age of sixty-seven or sixty-eight, retired from work at the Cottages in the early 1930s. Where she went and how she lived out her last years is not known.

THE COTTAGES AND REVEREND BOND

By the time Henry and John arrived at the Cottages on that chilly Valentine's Day in 1930—Gil and Mary would follow later—the Reverend Joseph Herbert Bond had been rector of St. Ann's Church for almost eight years. Reverend Bond served in that capacity until June 1, 1960, when the Reverend Peter Duncan MacLean took over as the third rector of St. Ann's Church. Reverend Bond, who had been rector for thirty-eight years, then served for an additional twenty-two years as rector emeritus, performing baptisms, weddings, funerals and usually leading one or more of the Sunday and church holiday services. At the time of his death in December 1984, Reverend Bond had served St. Ann's Church for more than sixty-two years.

Reverend Bond and his family had come to Sayville on January 1, 1922, some nine months after the Church Charity Foundation had accepted Ida Gillette's gift of property on which to build the Cottages. He replaced the ailing Reverend John Henry Prescott (1848–1923) as rector on July 13, 1922. Mr. Prescott passed away on January 13, 1923, less than one year after turning over the ministry to Reverend Bond. At the time of his death, the much-loved and respected Reverend Prescott was just shy of fifty years of service to his church and community.

Reverend Bond's residence, St. Ann's rectory, stood about two hundred yards due north of the Cottages, across Middle Road. Indeed, Mr. Bond would always be close both in proximity and spirit to the Cottages children. From the opening of the first cottage on July 5, 1924, until the Cottages closed in the summer of 1943, Reverend Bond dedicated himself to supporting the Church Charity Foundation children's program.

Documents and oral testimony show that Reverend Bond spent countless hours, much of it his own free time, working with and ministering to the Cottages' children and staff. Reverend Bond's children, Margaret (Peggy), Edith, Thomas and Joseph (Skipper), became schoolmates and Sunday school classmates of the Cottages children and their good friends. However, despite the intimate nature of the relationship between Reverend Bond and the Cottages, the structure of the Episcopal Church imposed limits on his power and influence over the children's care and upbringing. Reverend Bond was the rector for his Cottages' parishioners, but he was not in the same Episcopal Church organizational structure as the Cottages' superintendent. The four Cottages superintendents—Episcopal Sister Dorothy, Mary Erhard, Marie Levering and Episcopal Sister Lucy—all worked for the director of the Church Charity Foundation, the Reverend Charles Henry Webb. They did not work for Reverend Bond.

However, as their rector, Reverend Bond was very much a part of almost all aspects of the children's care. Just as Reverend Prescott had been known as the "marrying parson," Reverend Bond could have been known as the "children's parson." Mary Erhard often wrote about the significant amount of time Reverend Bond invested in ministering to the Cottages community, particularly the children.

Hank commented that of the four Whitehouse children, he was the closest to Reverend Bond, primarily through the church but also through the Boy Scouts. Hank said he only got as far as becoming a second-class scout with Reverend Bond's Troop 16, but the program afforded a positive experience and provided a kind of camaraderie and training that a boy, particularly a fatherless boy, could not get elsewhere.

Reverend Bond's Troop 16 was one of the oldest in the country, formed not long after the founding of the American Boy Scouts on February 8, 1910. Peggy Bond in her memoir, *Rector's Reminiscences*, said that Reverend Bond sought a charter from the national organization to establish a troop shortly after coming to St. Ann's on January 1, 1922. *The Suffolk County News* reports that Reverend Bond got his charter and started the troop in 1924.

Reverend Bond's Boy Scouts became Troop 1 because it was the first troop to form in Sayville. Scouting soon became so popular that two more troops formed in Sayville, designated Troop 2 and Troop 3. It was not until 1929, when the Boy Scout National Headquarters decided that its numbering system needed to be changed, that Reverend Bond's Troop 1 became Troop 16.

Troop 16 met on Wednesday evenings in St. Ann's Parish House, with the occasional meeting in the living room of Reverend Bond's rectory. Reverend

Bond managed to incorporate more religion into scouting than might be found in most of today's programs. For example, prayer was not an unusual scouting activity.

Reverend Bond's daughter Peggy tells us that Reverend Bond, who surely was ahead of his time, did the same thing for the girls. He established one of the first Girl Scout troops, even serving as the girls' scoutmaster until a woman could be found to take over. An article from the September 14, 1928 edition of *The Suffolk County News* says that Girl Scout Troop 1 met at St. Ann's Parish House on Wednesday afternoon with Mrs. I. Howard Snedecor and Miss Edna Wixom present.

Both of Reverend Bond's scout troops were important to the Cottages. Mary Erhard wrote that on October 22, 1932, she and five of the Cottages' Boy Scouts attended a rally in Oyster Bay at the grave of President Theodore Roosevelt. There they saw Roosevelt's pew at the local parish church and the tablet erected to his son Quentin, killed in France and buried where he fell. Later she wrote that the Cottages were in need of scouting paraphernalia: "We have five boy scouts and three girl scouts and they sometimes go about with a few more patches and somewhat shorter sleeves than the regulations call for."

Reverend Joseph Bond also involved children in other church-related projects. For decades he got high school–age boys from his congregation to cut down twenty-foot-tall cedar trees, set them up to outline the semicircle of the church apse and decorate them for the Christmas services. While some have said that Reverend Bond did this each Christmas to hide the Tiffany windows depicting scenes more closely tied to Easter, the boys who participated in the tree-trimming exercise knew there was more to it than that. If you asked them, the assisting boys would tell you they felt good about contributing to the church and the congregation through the creation of such a big and beautiful Christmas display. Reverend Bond undoubtedly knew that would be the outcome.

Reverend Bond also tried to gain as much participation in church services as possible from the children of his parish. Both John and Hank served as the crucifer, carrying the cross each Sunday at the head of the processional—the same cross that is still there today.

THE REMARKABLE
MARY ERHARD

As the Cottages superintendent, Mary Erhard was in a classic middle management position. She had almost fifty children and employees to manage while simultaneously answering to a number of "bosses." While CCF Director Webb was her immediate supervisor, he was only a part of the CCF Board of Managers. Other board members included church luminaries such as the rector of St. Ann's Church Brooklyn and, as an ex officio member, the Episcopal Diocese of Long Island suffragan bishop, Bishop Frank W. Creighton. Erhard also occasionally had to answer directly to the most senior official, the bishop of the Diocese of Long Island, Bishop Ernest M. Stires. Finally, she also needed to work cooperatively with the St. Ann's parish rector, Reverend Bond.

In addition to the church hierarchy, there were the church and CCF affiliated committees. This group included the CCF's Children's Committee, which oversaw the smooth functioning of the Cottages program. Then there was the Women's Committee on the Children's Cottages, chaired at the time by Mrs. William O. Reynolds of Brooklyn and made up of prominent and wealthy Episcopalian women from Brooklyn, Queens and Nassau and Suffolk Counties. These women contributed funding for a variety of expenses, including unforeseen emergency repairs to the facilities, the children's pay allowances and recreational activities, such as summertime visits to Jones Beach. Next, there was the group of wealthy independent and semi-independent donors who provided significant financial support, people such as Edwin P. Gould, Ida Gillette and a personal friend of Erhard's, Mrs. Isaac P. Hubbard, the wife of Dr. Isaac Hubbard of Richmond Hill, Queens, who also sat on the CCF Board of Managers.

Finally, there were the parents and extended family of the "inmates" who could, and often did, appear unannounced at the Cottages' front door. Mary Erhard's position truly required as much talent in the field of public diplomacy and organizational management as it did in child rearing.

What exactly was Mary Erhard's background that qualified her for the superintendent's position? Born in Hoboken, New Jersey, in 1884, she was the widow of the Episcopal Church Reverend William Joselin Erhard. She had traveled widely with her husband performing missionary work and was the author of many articles on Episcopal Church history and doctrines. While raising her three children, she taught elementary school in New York City for twelve years before coming to Sayville.

In her writings, the depth of her love for the children in her care comes through with clarity. She became protective of them almost to a fault, at one point even trying to minimize contact between the children and their parents or relatives. In early 1933 she wrote that she preferred that the children remain at the Cottages and parents and relatives visit there rather than having the children travel to them. She said it kept the children much healthier when they stayed with her. And in the early winter of 1932, she mentioned that she had unilaterally instituted a new rule forbidding wintertime travel for inmates. The new rule meant that the children could not travel to see relatives over the Christmas break or other winter holiday vacations. She later noted in her monthly submission to the *Helping Hand* that CCF Director Webb had overruled this dictate.

Mary Erhard approached her work at the Cottages with an intensity of purpose. In June 1933, she wrote a short prayer in her contribution to the *Helping Hand* about the goals she was striving for in her work. She wrote:

After all that is the great test which the Children's Cottages are beginning to meet now, after all these years of service; what will our children do that is worth-while after they leave us? How will our training wash? Has it produced young women and men whose principles of conduct are truly high and strongly rooted, who do not act finely to please (as a temporary measure) Sister Dorothy or Mrs. Erhard, but as a life principle and an expression of a Higher Allegiance? God grant it may turn out that the answer is YES.

Mary Erhard's prayer sounds like that of every parent. Her driven spirit also comes through in some of her other writings; for example, in September 1933 she wrote: "It is work calling for all anyone can put into it, and as

exacting as you like. Our reward will be if we can eventually see amongst our boys that character development for which we long and pray and live in hope. Nothing else can in the least compensate for what the task demands of heart and hand."

She wrote in by hand next to the passage, "But I did love it and them so much." Note that in this entry she mentions the boys but not the girls. Throughout her writing, she reflected the opinion that boys are far more challenging to raise than girls. Once she mentions that she had the children call her Mrs. Erhard, a titled name that she may have felt helped her keep those needing "character development" under firm control. One somewhat humorous passage in November 1932 suggests that at one point she had almost given up trying to refine the boys' behavior:

We could also use (if our readers will not laugh too much) some outgrown crockery and table silver. Our work is done by very young hands, and the breakage and loss is considerable, especially in the case of the boys' cottage. We have ceased trying to keep the boys in crockery that matched, replacement being too continual. Most boys are naturally careless, and accidents are frequent despite many warnings. We seem continually to need knives, forks, spoons, cups, mugs, glasses. Also, large vegetable dishes.

PAYING THE BILLS

Financing the Cottages was expensive, especially in the time of the Great Depression, and apparently little if any of the money came from the families of the inmates. The Church Charity Foundation's policy was that inmates' families should pay what they could to help cover costs, but the majority of families simply had little or no money to contribute. Hank said that while he agrees it is possible that Henry Sr. provided a financial gift either before his death or in his will, it could not have been much, and no known written or oral record of it has survived. No one else in the Whitehouse family would have been in a position to contribute very much, so it appears probable that the Church Charity Foundation provided the entirety of the funding for the Whitehouse children's upbringing.

Gifts and donations from individuals, particularly over the Christmas holidays, played an important supporting role in maintaining the Cottages' solvency. Mary Erhard understood this well and used her monthly column in the *Helping Hand* to get the word out early and often as to what she viewed as acceptable holiday contributions. In November 1932 she wrote: "Five dollars spent for food or clothing for the children will help us more than ten spent for toys soon broken anyhow. And will help to keep down the budget which is high enough in these days of limited income."

The very next month she petitioned her readers to give the children sturdy clothing. She wrote, "New, warm strong clothing will be a blessing— even what is not brand new, if clean, warm and serviceable [is acceptable]." She also asked for waterproof shoes, coats and hats. She requested combs, toothbrushes and bedroom slippers and explained the need for new wool blankets, boxes of buttons, a wheelbarrow and flower bulbs. The latter two

items were important because each inmate who wanted one had his or her own little garden plot, something Erhard saw as part of making each child's life a whole.

The next year Erhard began her holiday gift-soliciting campaign in the October issue of the *Helping Hand*. For that issue she had CCF Director Webb use his clout by contributing a short piece about what donors should consider providing at Christmas. Father Webb wrote:

> *For Christmas, please send only useful and necessary presents. While we are going in debt for food, clothing and coal, it is not fair for relatives to spend their money for luxuries. Such presents as sweaters, stockings, gloves, shoes, are a real help. Mark them with the child's name, if possible. If a book, let it be of the sort that will help develop the right ideals. If a toy, a simple and inexpensive one. Of candy, we always have too much. Please send such things as we would otherwise have to buy, and so make a Merry Christmas for both us and the children!*

In her last column of 1933, Erhard described the contribution made by the Cottages Children's Committee and others in helping the children celebrate Christmas. She wrote:

> *The Children's Committee again will give each child a wrapped gift of its own individual choice with its name on—just about the nicest thing anybody does for us at Christmas, I think. The personal touch means much to us. Then these gifts make each a fine nucleus for the stockings, which of course must all be hung, or it would not be a good old-fashioned Christmas. We should be very glad to have one tree for each cottage. Two years ago a circle of ladies in West Sayville did this, buying and sending in the trees at the proper time.*

In her own hand, Mrs. Erhard penned a brief Christmas tale in the border of the column described above. She wrote that a gentleman whom she had never seen before showed up at the Cottages late on Christmas Eve carrying a large bag. Almost miraculously, from the bag he produced a gift for each of the children. Apparently because of the late hour, the mysterious visitor met only with Mrs. Erhard and left as quickly as he had come. She wrote that she spoke very little with him and, unfortunately, never saw him again to thank him properly. She wrote, "I think he said he had been raised in an orphanage, and [provided gifts for every child] each year for some

The Cottages of St. Ann's

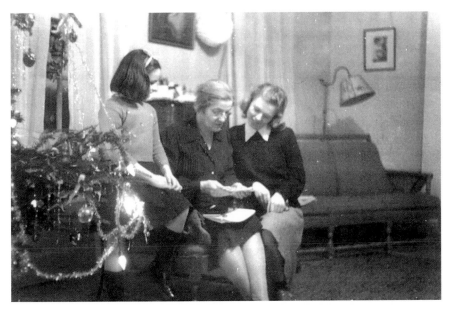

Christmas in the girls' cottage. Eunice McGlynn is the high school girl on the right. The identities of the younger girl and older woman are unknown. The photo was probably taken in the mid- to late 1930s. *Courtesy of Mickey Walker.*

orphanage he chanced to be near. It seemed like a fairy tale." Such a shame she did not write in greater detail about the incident, but then perhaps the story would not be as intriguing.

New clothing for the forty or so children was always the most pressing need; buying everyday items for so many active children was a constant financial drain. When shopping was required, Mary Erhard did the lion's share of it and forwarded the bills monthly to the CCF. In September 1933 she described the clothing situation:

> *Fortunately, it seems to come out that one or the other group* [of children] *has the more crying needs each season, which distributes the expense. Sometimes our friends buy articles of new clothing and send them to us; this is very nice. In these cases we recommend that the clothing be for children twelve or over. We can and do pass down clothing, but it is the larger children who need the most new clothing. We have dresses in the girls' cottage about which we recite a saga, "First it was mine, then it was, etc., etc., etc." It gives an individuality and a character to a dress to know its history, though I don't know how they remember it all.*

In one 1934 entry Erhard told of the precise costs of raising each inmate: "The actual cost per capita last year was a little more than $600. The 'orphans' endowment' amounts to $87,000, and can be relied on to produce each year say $4,300 or roughly $100 each for the children we have. Hence about $500 per year per child must come from other sources." Periodically the CCF, in concert with Long Island Diocese churches, solicited funds from all sources through the use of various fundraising techniques.

By 1934, rising costs prompted CCF Director Webb to begin a campaign he called "Adopt a Child," in which patrons contributed $500 to "adopt" a particular child for a year. In the spring of 1934, Mary Erhard wrote that she had told Father Webb that because her own son had grown to manhood she would contribute $500 to "adopt" one of the boys. Eventually the program offered adoption for whatever someone might be able to pay. For example, people were asked to contribute $50 to adopt a child for a month, or $12 for a week or even $2 for a day.

In describing finances, Erhard wrote, "These figures cover everything, including the fees that we pay the Sayville Public Schools." She added, "Then they have varying and sometimes heavy school expenses for 'Regents books,' etc." The money for these school extras came, at least in part, from the money the children earned doing jobs around the Cottages or during summer employment. Superintendent Erhard described the system used for providing the children with work assignments and spending money:

> *Every well child every month appears on the Work List and is assigned to tasks appropriate to his or her age, strength, and intelligence. For each task a small amount of money is given, so that the weekly allowance of each child depends on its own accomplishment...These jobs range from uprooting dandelion plants to cutting logs for the fireplaces, small repair jobs, driving the car* [the one car was a used Nash acquired in July 1932 to replace a 1925 Dodge. The Nash was chauffeured first by Herb Jemott and then by John Whitehouse after Jemott went on to college], *repairing of furniture, putting up new swings, etc. Of course the children, inasmuch as they are entirely provided for by us, are not paid on the scale of outside help, but only a little for each task; nevertheless, the amount for forty children adds up.*

In the summertime, the children who were old enough were encouraged to take summer jobs. They were instructed to save most of their earnings and contribute what was appropriate to the church offering on Sundays and

especially their little mite boxes during Lent. The idea behind the children earning money was not simply to teach thriftiness and charity but also to provide at least some money that might be used for their livelihood after leaving the Cottages. None of the children's earnings were ever intended for use in contributing to the costs of their Cottages room and board.

The Church Charity Foundation rules—strictly enforced—held that after a child graduated from high school, he or she must move out of the Cottages—no exceptions. If the child had saved some money, the transition to the outside world could be made somewhat easier.

Mary Erhard also addressed in her writing the need for money to support the children outside their daily expenses. She pointed out that the CCF recognized the need to finance higher education on a scale larger than what children might save from summer jobs. In her September 1934 column, she reported that CCF Director Webb had assumed "some additional financial responsibilities with respect to carrying on the education of a few boys and girls who have been with us in Sayville." She then discussed four children at various institutions of higher learning, including Herbert Jemott at the College of William and Mary, and added, "the Director will need during the coming school year about four or five hundred dollars more than he now has in hand." She let us know that Louise Walker, the first "Cottages kid" to graduate from Sayville High School, was also the first recipient of funding from the Educational Fund for her studies at the New Paltz Normal and Training School, today the State University of New York at New Paltz.

Erhard said that Webb handled the Educational Fund outside the budget of the foundation, so money must come from personal gifts and contributions. She said that a young mother, as a memorial to her deceased daughter, had started the fund.

Henry Whitehouse, who had become known as Hank, was a direct beneficiary of Father Webb's Educational Fund. During Hank's senior year of high school, Reverend Webb visited Sayville High School Principal Sam Munson to find out why Hank was interested in attending William and Mary and if Munson thought Hank capable of a good academic performance at such a fine—and expensive—institution. Munson assured him that Hank was up to the task and not interested in the school simply for its football team. Webb came away convinced, so using money from the Educational Fund, he paid at least some of the costs of Hank's undergraduate years at William and Mary.

All four Whitehouse children, indeed all the Cottage inmates, went to Sayville schools. When John entered school in the early spring of 1930, he was put back a year, undoubtedly because of the severe disruptions in his

young life. All the Whitehouse children began their schooling in the grand old Victorian-style wooden structure known locally as "Old '88."

Hank said that he and the other inmates walked to and from Old '88 and the new Greene Avenue high school every day, even in the worst weather (a round-trip distance of 1.5 miles, actually 3.0 miles per day because all the children came home for lunch). None of the children had bicycles or access to any other form of transportation for getting to and from school. For the little ones, it was a long walk in bad weather. Their route took them along Middle Road, past the Sayville Inn and Sparrow Park, past the Kensington Hotel, north on Railroad Avenue and across Swayze Street to the schools on Greene Avenue.

Old '88 was a gray, gothic Victorian-style wooden structure paneled on the inside with dark hardwood. The staircases were so narrow that traffic was only allowed in one direction. Not only was going up the down staircase not allowed, but it was also impossible. By today's standards, the building would have been condemned and the school district probably sued for even considering exposing children to such an extreme fire hazard, a disaster just waiting for a spark. In a strong wind, the entire building would creak and groan like a Halloween haunted house, but to the Whitehouse children and surely many others who went there, Old '88 always had something warm and appealing about it.

Sadly, on December 14, 1969, in a ferocious blaze, Old '88 burned to the ground. Years later, the town finally got around to putting up a commemorative sign. The town's sign thanks Old '88, the building, for providing so many years of service to the Sayville community. Today, a new library sits on the site.

Most Cottages inmates went to high school in the new building on Greene Avenue. The cornerstone for this building was laid in January 1927, with the building completed in 1928 at the cost to taxpayers of $338,000.

In September 1928, the school was home to Seward S. Travis, who was the supervising principal of Sayville schools. Later that year he would be made superintendent. Sayville High School had a total of 226 students. Kindergarten through the junior high school grades accounted for another 646 children, for a total enrollment of 872. This figure was 50 students, or about 6 percent, more than the year before. The numbers would grow rapidly as the years passed and would include many children from the Cottages.

Just before the Cottages were to close, in the spring of 1943, *The Suffolk County News* carried an article that said, in part, "Their closing will be something of a blow to the [Sayville] school district since the Church

The Cottages of St. Ann's

Charity Foundation has paid annual tuition of $100 per pupil." Indeed, forty-three children in Sayville schools cost the CCF $4,300 per year plus added expenses, a not insignificant sum in the Depression era. Costs would eventually mean the closing of the Cottages. The same 1943 *Suffolk County News* article cited above also reported:

> The decision to close the cottages at the end of the present school year has been known hereabouts only for the past week. Sister Lucy, the housemother [actually she was the Cottages superintendent but probably also was serving as a housemother], told a reporter for The News yesterday. It is due entirely to financial reasons and to the fact that under wartime conditions the Church Charity Foundation had a deficit of $70,000 at the end of the past year. The work at St. John's Hospital and the work at the Home for the Blind they felt could not be discontinued but the Children's Cottages, which are maintained at a cost of about $18,000 a year, they decided would have to be.

EVERYDAY LIFE

The children were brought up with a heavy dose of religion. Mary Erhard, who seems on occasion to have been as much drill sergeant as diplomat and surrogate mother, described the weekly routine as follows:

> *Up at seven-thirty on Sunday for the eight o'clock service at St. Ann's and home again at eight-thirty for breakfast. Return to church at nine-thirty for Sunday school. Some of the older children also attended the eleven o'clock service at Rev. Bond's request in order to hear the sermon. The afternoon was for recreation. Supper was at six o'clock followed by more play until Evening Prayer, which was at eight in the boys' cottage with Rev. Bond.*
>
> *Monday through Friday everyone was up at six-thirty. At six-fifty the children met in their sitting room for a hymn and morning devotions conducted by the housemother. Breakfast was at seven. House inspection for beds properly made and rooms cleaned was at eight fifteen, with the children leaving in time to reach school by eight forty-five. Except in the worst weather, the children all returned for lunch, which is at twelve-fifteen then quickly returned to school. School was out at three-thirty. Supper was at six o'clock followed by prayers, Bible reading and a hymn. Children under the age of ten were in bed by seven-thirty, ten to twelve year-olds retired at eight. Those who were twelve and thirteen years old went to bed at half past eight and those fourteen and older at nine. On Saturdays everyone was up at seven with the morning devoted to cleaning. The afternoon was for recreation.*

Life at the Cottages was not a completely Spartan existence. In early 1933, in the common room of the boy's Canon Swett Cottage, Mary Erhard

installed the building's first radio. In May 1933, she wrote that she still owed $14.55 on the purchase and hoped someone could help pay it off. She also noted that it would take another $10.00 to repair the radio that was in the Gray House.

Mary did not see the radio as a luxury; in fact, she embraced it, calling it essential to "family life." She wrote:

> Each cottage really needs a sort of center for family life; nowadays the radio provides it. It is not always easy to make a large number of children of different ages feel that they are one family and have a family life. Meals and prayers should not be the only time we meet; the constant tendency to get off in small groups is not a desirable one, and makes for the reserved, silent, unresponsive, institutionalized child.

In both the girls' and boys' cottages, everyone gathered around the radio to listen to the most popular radio shows. Hank remembered that one of the favorites was a CBS program begun in the summer of 1933 called *Jack Armstrong*. The adventure show, sponsored by Wheaties breakfast cereal, featured Hudson High School student Jack Armstrong and his two friends Billy and Betty Fairfield. In 1950, Jack Armstrong became a government agent and the show was renamed *Armstrong of the SBI*. Later in life, Hank joined the federal government, eventually becoming an administrative law judge. Could it be that the radio show had some influence on Hank's choice of careers? Hank said he thought maybe it did.

Another favorite show of everyone at the Cottages was *Don McNeill's Breakfast Club*. It also began to broadcast in the summer of 1933 and ran until December 1968, with McNeill covering mostly American news and entertainment stories. Also popular was Bing Crosby's weekly radio show on CBS radio. In 1936, the Cottages family followed Bing when he moved to host NBC's *Kraft Music Hall*, a weekly show that broadcast until several years after the Cottages would close.

Concerning mealtime at the cottages, Hank said that he served as the boys' dining room table captain. This meant that it was his job to maintain order and decorum during meals. He said the only problem he ever had was with boys who were too lazy to lift their forks to their mouths, preferring instead the "mouth to plate" technique.

The Cottages were not without their romances. Eunice McGlynn (Mickey Walker) dated Gilbert (Bud) Whitehouse in high school. Ms. Walker said that Margaret Jemott, Herbert Jemott's younger sister, was a girlfriend of Hank's.

Believed to be Christmas dinner in the dining room of the Burgess (girls') Cottage. *Courtesy of Warren McDowell.*

Even the straight-laced Mary Erhard described social occasions when the girls' cottage would host a party for the boys and vice versa.

Mary Erhard's writings reflect her desire to make life at the Cottages as much like a normal home life as possible, and what could be more typical of a normal American home than having a dog? In the September 1933 column of the *Helping Hand* she included a rare picture. The shot is of three of her boys, apparently dressed for the first day of school, standing in front of the Canon Swett Memorial Cottage. The caption reads, "This picture shows three of our boys at Sayville, Henry Whitehouse, our biggest (though not oldest), and Bobby Richardi and Clifford de Bruhl, our smallest; not to mention the dog." Hank told us the dog, named "Chubby," was a mixed breed with a coat of long black and white fur. Chubby was at the Cottages when he and John got there in February 1930 and was there when Hank left in the early summer of 1937. Where Chubby came from or whatever happened to him, Hank did not know.

Sometime not long after the summer of 1937, Chubby appears to have been replaced by an equally beloved canine, this one a purebred Irish setter named "Kim," or sometimes "Kimie." We know about Kim, who had been donated to the Cottages by Sayville's Regina Arata, because of an April

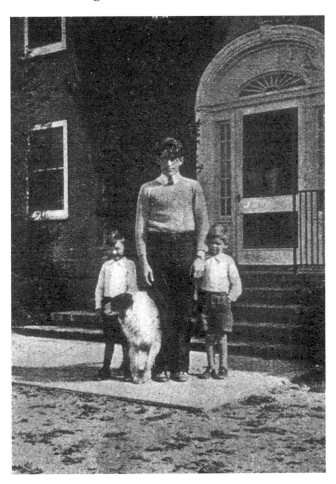

Chubby the dog with Hank and inmates Bobby Richardi and Clifford de Bruhl standing outside the front of the boys' cottage. The photo was probably taken in early September 1933. *Courtesy of the Sayville Historical Society.*

1942 *Suffolk County News* story about him. It seems Kim escorted the children to and from school every day. He was following one of the girls home from school late on Monday evening, April 13, when he was hit by a car driven by George Laidlaw of Bayport. Mr. Laidlaw immediately reported the accident to the local police. Sayville patrolman Everard Case managed to locate the frightened animal and notified the Cottages. Kimie was then rushed to the vet, where he was treated for cuts and a fractured hip.

Sister Lucy, then superintendent of the Cottages, told the paper, "The $9 or $10 it cost for Kim's treatment at the dog hospital will probably be paid for by the children. One of our girls offered to give up her whole allowance. All the other boys and girls are anxious to contribute too." The *News* also reported that Sister Lucy intimated that consideration for the

cost led to Kim's early return from the vet but suggested that perhaps it is better that he's back home with his leg in a cast and certain of plenty of regular attention.

John's one brief personal story about domestic animal life in and around the Cottages was that he had a large pet rabbit named Butch. The entire story was that he trained Butch to come when he whistled for it. He never said how he got Butch or what happened to the creature or anything else about it. But he obviously loved the animal in his own way. Hank said that John had more than one rabbit; in fact, he had several he raised as pets. Mary Erhard also wrote about the care and feeding of his rabbits.

John always had a remarkable affinity with domestic animals, from dogs and cats to rabbits and birds. They seemed to react instinctively to something about him, as though he and they knew something the rest of us didn't. In later years, even though his wife Betty fed them, walked them, cleaned up after them and otherwise ministered to them, it was to him the family dogs, cats, birds and assorted other creatures listened.

In the summer of 1933, Mary Erhard wrote that one of the boys had been offered a rowboat at a very low price and was buying it from its owner on an installment plan. She described the ingenuity displayed by some of the boys with this lowly old rowboat:

> *This is no longer a mere rowboat: he and the others have rigged it up with a sail—or rather sails. The fact that these sails were originally shower curtains in our bathrooms robs them neither of use nor beauty; and as they are a delightful green I know a long way off that my boys are safe—there being no other green sails in use hereabout. The boys cut off the mildewed sections of the curtains, and the results are really surprising. Also the skill in sailing being developed.*

One wonders if the boys manning this shower curtain–powered rowboat weren't eventually to become participants in the local sailing group known as the Wet Pants that would start up only a year later in 1934. Unfortunately, Mary did not mention the sailors by name.

Ida Gillette must have known that the Cottages property would make a wonderful location for a child, with its pristine undeveloped open space, right next to Brown's River and near the Great South Bay, places fit to capture anyone's imagination. In many ways, the South Shore estuary defined John. Throughout his life he loved the water, the wetlands and all the creatures found there.

The Cottages of St. Ann's

For some of the children, the property was not quite as wonderful as it was for John. Poison ivy was an omnipresent green plague, particularly for children with a susceptibility to contracting the itchy rash from even the slightest contact with the prolific plant. Mrs. Erhard organized work parties of some of the older children to try to rid the grounds of the shiny-leafed vine, but to no avail. It just kept growing back. Hank, for one, found it difficult to live through the warmer months without scratching either a poison ivy rash or mosquito bites. Even Mary Erhard complained frequently about the mosquito infestation from the nearby brackish marshes, describing the spring as the best time to visit the Cottages because it was before the mosquitoes arrived.

Mary Erhard wrote a good deal in her monthly columns in the *Helping Hand* about the recreational activities of the inmates, and John was often featured. But work, for all ages and both genders, was always part of the equation. In July 1933, Mrs. Erhard cited clamming, not only as recreation but also as a source of food for the Cottages and an activity that sometimes earned the children "real money."

As mentioned previously, when old enough, the children were expected to take paying jobs in the summertime. For most of the boys, summer work focused on gardening and landscaping and, for the girls, baby-sitting and similar activities. Hank said he used to mow lawns in Bayport with an African American named Bill who operated a large power mower, while Hank did the trim with a push mower. Hank believes that Bill was also one of Father Divine's followers and specifically recalls Bill repeatedly telling him, "Hank, this earth is heaven!"

In the summer of 1936, Sayville experienced a severe drought, so there was no need for mowing. Hank left Bill's lawn care business and got a job in Roulston's grocery store, which was really two connected stores—a butcher shop on one side and everything else on the other. Roulston's was located opposite the head of Candee Avenue, on the north side of Main Street. Hank also was employed in 1936–37 by the Town of Islip to raise and lower the flag every day at Sparrow Park. As we know, the money to pay Hank for his work at Sparrow Park came from the endowment left to Islip Town by the former owner of Sparrow Park, Ida Gillette.

Hank commented that John practically lived in the water in the summertime and eventually worked regularly as an assistant to the owner of Nick's Clam Bar, where he became a true master at the cleaning and preparation of every manner of the abundant fish and shellfish to be found in the local waters.

In early October 2006, Bernard "Barney" Loughlin reminisced about Nick Munsell's Clam Bar while tending to the fire in his small wood cabin at his vineyard in eastern Sayville. He said old-timers will remember that Nick's Clam Bar was actually a small barge moored to a couple of wooden stakes just to the south of what is now called Bryan's Bridge on the western side of the river. Barney said that John was not the only local boy who worked for Nick shucking clams and oysters and cleaning fish; Barney worked for him, and others did, too, because the pay was thirty-five cents an hour— very good money in the days of no jobs and the Great Depression. Munson owned and operated his clam bar until about 1946, when he left and some other folks took over the barge, if not the business.

The Whitehouse children were all a few years older than Barney, but he knew them quite well because they were practically next-door neighbors; Barney's father had been the keeper of the Roosevelt's Meadow Croft estate until Barney took over the job in April 1945. Barney said his father liked all the Whitehouse kids because "they were good kids." Barney remembered both Hank and John as exceptional athletes for Sayville, especially Hank because he was so big and strong. It wouldn't be until the early 1980s that Barney would begin his highly successful vineyard on a six-acre tract of the Meadow Croft estate just south of the Long Island Rail Road tracks.

Mary Erhard also occasionally praised in her writings some of the local residents unaffiliated with the Cottages for their volunteered services. A Miss Maxfield of Patchogue is cited for donating music lessons to Cottages children with an interest in learning to play the piano. A couple of years earlier, some thoughtful soul had donated a piano that stood in Gray House. Mary Erhard wrote that the piano lessons were so successful that on June 23, 1934, a recital was held, at which six outside guests were in attendance.

One citizen who was twice singled out for his generosity—in Mary's July 1932 column and again in her August 1933 column—was Captain Fred Stein of the Sayville ferries. In 1933, Mary wrote:

Through the kindness of Fred Stein, operator of the ferries, the children, with Miss Coen [housemother for the younger girls] *and me, were taken free to Cherry Grove on July 13th. A happy day was spent on the beach, where we bathed in the ocean which is more exciting than the bay or the river—our usual swimming places.* [Mary later identifies the usual swimming location on the bay as Sykes Beach, between Foster Avenue and Brown's River Road. And for Brown's River, it was the waters immediately adjacent to the Cottages.] *It was*

The Cottages of St. Ann's

the first time some of the younger ones had seen the ocean. Pails and shovels provided entertainment for the eight youngest, while some a little older unbent enough to dig in the sand a considerable amount too. Captain Stein found time to be an ideal host on the boat, besides his duties in operating same.

Fred Stein is also indirectly mentioned in other columns as having provided the children with free transportation on his ferries to and from Cherry Grove on a number of occasions.

Many other townsfolk donated or gave away at very low prices everything from rowboats and radios to pianos and cars, contributing greatly and anonymously to the children's quality of life. Mickey Walker said that she received a great deal of personal attention and help from a wonderful local lady named Ada Silliman, the wife of Dr. Grover Silliman. Invitations to the Silliman home and to go on outings made Mickey feel special. Similarly, many of the other children had unsung local heroes and heroines who tried to take a child under their wing.

There were also all the unnamed people who hired the children in the summertime so they could earn a little spending money during the height of the Great Depression. Finally, there were the local physicians, Drs. Eller, MacDonnell and Winston, who not only made house calls for the children and staff but also did it for free. Sayville dentist Roland Strong, with offices in the old post office building on the north side of Main Street, provided the children with dental care. Mickey Walker commented that as a child she made frequent visits to his upstairs offices reached via a staircase in the back of the building.

The Cottages' children's health also benefited from the CCF's connection to St. John's Hospital. When necessary, the children went to St. John's for treatment. In one of her monthly columns, Mary Erhard wrote that Louise Walker had to have her appendix out. "Of course she was in St. John's for the operation. I never tire of announcing that our children begin to get well as soon as they pass through those doors."

In 1933, Erhard wrote: "One little pair of tonsils came out of a girl at the hospital this month, and three other children anticipate the somewhat dubious pleasure of losing theirs in December. It seems as though our relations with St. John's were particularly close this season."

Today, St. John's Episcopal Hospital South Shore is a 335-bed teaching hospital located in Far Rockaway, and the Church Charity Foundation (CCF) is the Episcopal Health Services Inc. (EHS).

MORE THAN JUST
SPORTS

In the 1920s and 1930s, high school sports teams played a significant role in small-town life. For families without television, and many without even access to radio, the opportunity to watch local boys compete was important. Baseball, basketball and football were the big three, with legions of citizens attending games to root for their team. The popularity of the games brought to the young people a sense of contributing and a feeling of belonging in their community. Kids learned personal sacrifice, how to perform under pressure and the difference between winning and losing. These learned qualities would prove essential to the nation's military in facing the huge challenges of the early 1940s.

While boys from Sayville High School had played against boys from other local schools in football for a number of years, *The Suffolk County News* reported that it was not until October 1928 that Sayville High School received official sanction for the formation of a football team.

The *News* also reported that on Saturday, November 3, 1928, Sayville High played its first officially scheduled football game, beating Westhampton in Westhampton by a score of 12–0. The team had nineteen players—eleven starters and eight substitutes. Before the game, *The Suffolk County News* reported that the Sayville team featured "Buck" MacKenzie at fullback and Joseph St. Lawrence at quarterback. The paper reported that MacKenzie "can kick, pass and plunge the line." Sure enough, the near legendary local athlete starred, scoring both touchdowns.

The following Tuesday, November 6, the Sayville team played the Patchogue High School Junior Varsity team in Patchogue, winning that game by a score of 18–0. On November 10, the Sayville eleven played their third and final game of the season, losing to Greenport 39–12.

All the games had to be "away games" because, in 1928, Sayville did not yet have a football field. But at least the 1928 season was a start. After the Greenport game, Coach—and Sayville Athletic Director—Clifford Gustafson told *The Suffolk County News* that Sayville had entered the Suffolk County Football League and would contend next season with the "Patchogue, Amityville and Port Jefferson watermelon tossers." The ball used in that day actually resembled a watermelon, unlike the more streamlined ball used today.

The Sayville boys couldn't wait to play the still relatively new game popularized by the exploits of the famous Notre Dame football teams of the 1920s under Coach Knute Rockne. Between 1919 and 1930, Rockne won six national championships featuring such legendary players as George "Gipper" Gipp and the "Four Horsemen." The high school boys dreamed of reaching such exalted heights of sports fame. But, in 1929, the best the Sayville team could do was to battle rival Patchogue to a close finish, losing by a score of 10–6.

In 1930, with Ed Minka as the new coach, the season was canceled shortly after it began because too many of the Sayville players had been injured. Injuries were easy to come by, with protective equipment in only the nascent stages of development. With soft leather helmets and without benefit of facemasks and teeth guards, inexperienced players stood an excellent chance of some pretty nasty injuries. So the remainder of the 1930 season was dedicated to Minka teaching the fundamentals of the game to those who could still play and to younger kids who might want to play in the future. The only year that no games were played was 1943, and that was because of transportation problems brought about by World War II.

The 1932 yearbook reports that the 1931 team went 0-2, losing to Port Jefferson and Smithtown, with physical education teacher Harvey Case pressed into service as a "substitute coach." The 1932 team finished a disappointing 0-5, scoring only one touchdown the entire season, but the spirit was there— Coach Case had thirty-five boys suited up to play each game.

Beginning in 1930, the soft-spoken Harvey Case served as director of physical education and athletics at Sayville schools. In the early years, he functioned not only as the football coach but also as the basketball and the track coach. He was the coach for many of Sayville's Long Island championship track teams of the 1930s, including those on which John, Gil and Hank participated. Hank described Coach Case as a wonderful human being who performed far beyond what was required of him as a teacher and coach. It is difficult to put into words the role a man such as Harvey Case played, but he was a father figure when he was needed and an invaluable inspiration for all three Whitehouse boys in their teenage years.

Coach Harvey Case is standing almost directly in front of John. This team also won the Long Island Track Championship. The last names of some of the others in the photo are Jedlicka, Welton, Kwaak, Newhouse, Mead, Zegel, Miller, Veryzer, Seerveld, Pisani, Silliman, Bernstein and Griek.

But back to football—in the fall of 1933, the Sayville eleven tied Huntington in the first game of the year. This represented Sayville football's first non-loss since 1928 and was cause for great local celebration. Unfortunately, Coach Case's boys lost the remaining four games of the season, but at least the ice had been broken.

For the fall campaign of 1934, future Sayville High School Principal Tillman Wenk, or "Tilly" to almost everyone who knew him, took over the head coaching duties. *The Suffolk County News* took to calling the team the Wenkmen. Under their new coach, the team finally won a game, defeating Port Jefferson by a score of 19–0. *The Suffolk County News* reported that at the end of the regular season Sayville challenged sports arch rival Patchogue to a postseason game, a challenge Patchogue quickly accepted, believing they could easily defeat the Sayville eleven. As it turned out, the game was close throughout, with Patchogue leading by 6–0 until the final minutes, when a blocked punt allowed a second Patchogue touchdown. Patchogue won the game 12–0.

The results for the 1935 season were about the same as the year before except that instead of a single victory the team managed a single tie. In the first game of the season, Sayville "defeated" Patchogue in Patchogue by a score of 6–6. It was the first time Sayville had not lost to a Patchogue football team since 1928 and so was seen as something of a real victory.

Patchogue was a major Sayville sports rival in almost every sport, a rivalry on the order of the Boston Red Sox and the New York Yankees, Army and Navy, Texas and Oklahoma. *The Suffolk County News* reported that Sayville-Patchogue football games of the mid-1930s drew crowds of as many as 8,500 paid entrants. The game was a significant local event, with reputations and bragging rights for

the entire year depending on the outcome of the contest.

The first game of the 1936 season was at home on Saturday, September 26, at Dow Clock Field—the official name of the playing field next to the Greene Avenue high school. It was the annual contest against Patchogue, and by all predictions, it promised to be a thriller. An article in *The Suffolk County News* encouraged everyone in town to show up for the game. The game lived up to its hype. In the closing minutes of the fourth quarter, Sayville got a touchdown to make the score 7–6 in Patchogue's favor. Then, Sayville quickly got the ball again and drove to the Patchogue ten-yard line. But the clock ran out, and Sayville suffered a heartbreaking loss, 7–6.

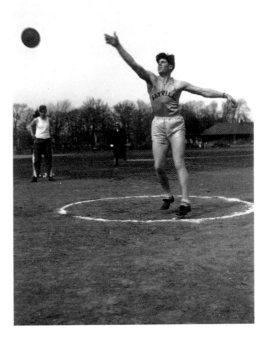

John throwing the discus 121 feet, 9 inches on May 9, 1938, in a meet at Dow Clock Field. The Sayville train station is in the background.

The late, great Green Bay Packers coach and Brooklyn native Vince Lombardi famously said, "I firmly believe that any man's finest hour, the greatest fulfillment of all that he holds dear, is the moment when he has worked his heart out in a good cause and lies exhausted on the field of battle—victorious." He could have left off the word victorious. John used to say that competing in a game such as Sayville's 7–6 loss to Patchogue in an odd sort of way leaves the losers more energized than the winners.

Later in the season, the 1936 Sayville team, captained by right tackle Hank Whitehouse and featuring quarterback Nunzio Pisani, beat Babylon and tied Lindenhurst, giving them an overall record of one victory, one tie and four losses. It was Tilly Wenk's last season as head football coach, but his team finished the season tying Sayville football's abbreviated 1928 season for best record ever. And while Hank's teams did not do very well, Hank played well enough to be able to gain a football scholarship at William and Mary.

For the 1937 season, Vernon Eales took over as the head coach, and the season's results remained dismal. But Coach Eales, an aggressive and dynamic

personality, had set to work building a real team. By 1938, Eales finally put Sayville High School football on the local football map. The season was what fans had been waiting a decade to experience. Sayville won five of its seven games, beating Babylon 39–0 and Smithtown by the same score and besting Patchogue—for the first time ever on the varsity level—by a score of 12–0. It was Sayville's first honest to goodness winning season. Two Sayville players were named to the All-County team: fullback John Whitehouse, who was only a junior, and senior end Wallace "Wally" Wachlin. The two are believed to be Sayville's first All-County football players. Sayville has been fortunate to have many such players since then.

The names of the twenty-five members of the 1938 Sayville High School football team read like a short list of longtime Sayville families. Some of the members of this first winning team included team captain Lawrence Griek; ends John Veryzer and Herbert Terry; tackles Kenneth Stein, George Miller and Bill Welton; centers Robert Antos and Fred Stein; halfbacks Joe Jedlicka, Joseph Mead (also from the Cottages) and Saul Bernstein; guard Stanley Thuma; quarterback Edwin (Icky) Stein; and fullback Albert Van Essendelft.

All their lives, John and Hank remained proud of playing high school football. Cottages Superintendent Mary Erhard, in her writings for the CCF, enthusiastically mentioned the boys' participation in the sport. As an adult, one of the few things John would talk at length about from his youth was playing football. He liked the people with whom he played, and he loved to brag about being named to the All-Suffolk County team. John's coach, Vernon Eales, wrote in his yearbook that he was the best fullback he ever had. Of course, one might ask, how many fullbacks did Coach Eales ever have? But that would be missing the point. This was a substitute father praising his son. Nothing could be more important to the younger man.

Eales, with his dynamic, upbeat personality, was a tremendously positive influence on his fatherless high school football player. John thought the world of Vernon Eales, who even in later life encouraged his orphan fullback to continue to perform as well in life as he had on the gridiron.

Unfortunately, John didn't play at all in 1939, his senior year, because he had injured his knee so badly at the end of the 1938 season. Hospitalized for a prolonged period of time, he missed many weeks of school. Perhaps the greatest compliment to John's talents as a ball player came in the early fall of 1939, when he could not play. The compliment came from Joseph "Joe" Jahn, who in the fall of 1939 was an associate editor for *The Suffolk County News*, writing, among other things, the local sports column. (Jahn would eventually take over as editor of *The Suffolk County News* following the death

of Francis Hoag and would win many awards for the weekly newspaper.) For his Friday, October 6, 1939 sports column, Jahn led off with the following poem, which he entitled "Ode to a Knee":

Yeah, we'd show 'em a thing or two,
The season'd be in the sack,
We'd kick those guys black'n blue—
If Whitehouse were only back.

Alas, his knee is on the bum,
A triple-threat star we lack;
Sure, we'd belt 'em to Kingdom Come!
If Whitehouse were only back.

Oh, great the gloom this fall,
Our fans are hiding their jack;
We'd have plenty on the ball,
If Whitehouse were only back.

Jahn went on to describe Sayville's loss to Huntington the previous Saturday afternoon by a score of 13–0.

John, like his three siblings, was an outstanding all-around athlete. The 1940 Sayville High School yearbook shows him on the varsity football team for the first three years of high school, a varsity basketball player for two and a varsity track team member for four. He was also class president for four years (1936–40) and had a lead role in the senior class play. One line from his 1940 yearbook says, "John Whitehouse, class president, line plunger, trackman, Boys' Stater, a record for underclassmen to shoot at." It was all good training. But it wouldn't be the underclassmen shooting at him. No one realized it when John graduated from high school in June 1940, but only eighteen months later the United States would desperately need intelligent, athletic, courageous young men to fight the battles of World War II.

The strict—by today's standards—Cottages regimen seemed to help all of the Whitehouse children. And from the comments of other inmates such as Mickey Walker, by far the majority of Cottages children benefited. The 1937 high school yearbook shows that Hank was his freshman and senior class president. He was a varsity track team member and football player for all four of his high school years, as well as a member of the glee club. Hank also composed the poem that begins his yearbook.

This photo was taken on the south steps of the Greene Avenue high school probably in the late fall of 1939. It shows the 1940 Sayville High School yearbook staff. Doris Kaiser and William Friedberg were co-editors. The faculty advisor (not pictured) was the longtime Latin teacher, Letetia Washburne.

In June 1941, John's brother Gil graduated from Sayville High School. For decades, Gil held the Suffolk County high jump record at a height of six feet, two and a quarter inches. A piece of the crossbar was displayed in the Sayville High School trophy case until the late 1960s. He was also an exceptionally good high school cross-country runner, placing second in the county meet his senior year. It's unfortunate that in later life John, who was very close to his younger brother, rarely spoke of him. The reason he would not talk about Gil was that it was too emotionally charged a subject—a tragedy he would never completely get over.

The youngest Whitehouse child, Mary, who graduated from Sayville High School in June 1942, was also popular with her classmates and a class leader, as evidenced by the fact that she was a class officer all four years. She was also coeditor of the yearbook and on the girls' all-star softball, basketball and volleyball teams. Her picture appears throughout her senior class yearbook as a member of clubs, associations and sports teams.

ERHARD FORCED OUT

Mary McEnnery Erhard served faithfully as the Cottages superintendent for five years, from 1930 to 1935. The diary she kept during that time reflects her dedication to the job and her deep love for all the children in her care. Then suddenly, in 1935, she departed her post for reasons that to this day remain a mystery. It appears that the Church Charity Foundation abruptly terminated her employment, but why they did so is not known. Erhard's diary hints that one of her assistants, a young girl named Marian Levering, may have been responsible. But what role the young Miss Levering played in Erhard's being let go is unknown. With so little hard information to go on, it must be said that Erhard's dismissal might well have been little more than church politics, as we shall see below.

There are several reasons for suspecting the CCF fired Mary Erhard. First, she left her post without warning, explanation, ceremony or farewell. Second, she wrote in her diary next to the name of young governess Marian Levering, "Alas, alas, alas for Mc En. She was my nemesis." (Note: Erhard used "McEnnery" as a middle name; in all probability it was her maiden name. She used the abbreviation "Mc En" to refer to herself in several places in her diary.) And finally, she penned another note at the end of her final—and abbreviated—contribution to the *Helping Hand* that says, "Abridged. Blow had fallen by then."

Whatever the reasons behind her sudden departure, Hank said that some months passed before Erhard's replacement arrived. And who was the new director? The new superintendent was none other than Marie Levering, the older sister of Erhard's identified "nemesis," Marian Levering. Marie Louise Levering came to the Cottages from Minnesota in early September 1935.

It is important to note that new Superintendent Marie Levering's arrival at the Cottages had been preceded not just by the arrival of her younger

sister Marian two years before, in the late summer of 1933, but also by a December 1933 visit by her father, Reverend Lewis R. Levering.

In the January 1934 edition of the *Helping Hand*, Mary Erhard wrote that Marian's father, Reverend Levering of Fairbault, Minnesota, had spent Christmas weekend at the Cottages. Erhard does not provide the reason for the visit. One could speculate that perhaps there were problems with young Marian adjusting to Mary Erhard and the Cottages—a possible harbinger of Erhard's problems to come. Hank commented that Marie and younger sister Marian were quite different people. Hank found Marian to be capricious and flighty by nature, while Marie was mentally strong and purpose driven. In any case, surely Reverend Levering's brief visit in December 1933, all the way from Minnesota and in the depths of the Great Depression, was made for a reason. Sayville was a long way from Minneapolis and not a cheap or easy journey for a social visit.

Writing in the *Helping Hand*, Erhard said that Reverend Levering was chaplain and math instructor at the "Shattuck School" in Fairbault, Minnesota, a town located about forty miles south of Minneapolis. From his position we may assume that Reverend Levering was quite familiar with institutionalized children and likewise familiar with many of the problems facing Mary Erhard. In fact, this meeting may have been a friendly and cooperative one. We will never know, but it is interesting to note that only two years after Marian Levering's arrival and a year and a half after the Christmas visit of Reverend Levering, the reverend's older daughter, Marie, took over as superintendent of the Cottages following Erhard's abrupt departure.

As superintendent, Marie Levering was a significant change from Mary Erhard. Unlike Erhard, she had never had any children of her own; in fact, she had never married. Also, Levering was a physically large and socially gregarious woman with something of a passion for food. Hank commented that in the late 1930s Marie's robust physical proportions caused her to develop health problems, with doctors eventually diagnosing her with Type 2 diabetes. Following the diagnosis, she became quite serious about improving her health, adhering to a good diet and regularly going for long walks.

Hank said that sometime after Marie Levering took over as superintendent, her father came and stayed for an extended period at the Cottages. It is possible that his visit occurred during the 1936 summer break at the Shattuck Military School. Mickey Walker commented that in subsequent years Reverend Levering visited quite often and that he was a favorite with the children. Given the frequency of his visits, it is possible that Reverend Levering played an administrative role within the Church Charity Foundation.

The Cottages of St. Ann's

In December 1933, Reverend Levering's "'Shattuck School" was actually a military academy, with its full name the Shattuck Military School. In 1974, it ceased to be a military academy and became the Shattuck–St. Mary's School. Today, the 250-acre campus serves a student body of 380 in grades six through twelve from twenty-seven states and twenty-five countries. The school was founded in 1858 and claims it is one of the oldest college prep schools in the Midwest.

At this school, Marlon Brando reportedly began his acting career. His signature may still be seen "on the green room wall"—a reference to one of the school's buildings. Marlon's father was a graduate of Shattuck Military, but the stage and screen star was a dropout. The Shattuck Military School booted him out as an incorrigible before he could graduate. It is said that Brando went into acting because there was nothing else he could do. He was even rejected by the military because of a knee injury suffered while playing football at Shattuck.

In the summer of 1944, only a few years after getting the boot from Reverend Levering's Shattuck Military School and then attending acting school in New York City, Marlon Brando performed for Edith Gordon at the Sayville Summer Playhouse on the Great South Bay at the foot of Candee Avenue. According to Charles Dickerson's *A History of the Sayville Community*, Gordon "discovered" Brando during a visit to Fire Island's Cherry Grove, where she met him at a bar and signed him for the lead in her show. At the end of the summer of 1944, Brando went from Sayville to Broadway and starred in his first Broadway show, *I Remember Mama.*

One cannot help but wonder if Reverend Levering had any influence on young Marlon Brando, including his working in Sayville. After all, among theater folk, Sayville was well known in the first half of the twentieth century. Preceding the Sayville Summer Playhouse was the Sayville Opera House, which seated 1,500 people, located on the east side of Candee Avenue just below Main Street. In 1961, it burned to the ground, but in the early decades of the 1900s Dickerson tells us that it had the largest and best-equipped stage and dressing rooms on Long Island, with New York companies using the theater for rehearsals before going on Broadway.

Reverend Levering may or may not have had an influence on the future of Marlon Brando; as for Marie Levering, she was a big influence on John. In the course of their five years' of close association, from September 1935 to July 1940, John and Marie Levering became very close. Marie Levering would eventually receive a prominent place in Betty and John's July 17, 1944 wedding in Brooklyn. She also became very close to John's younger brother Gil and sister Mary.

LIFE AFTER THE
COTTAGES

In the summer of 1940, thanks to a summer employment program run by Sayville schools, John got a job working for a prominent Sayville physician by the name of Wittmer. The doctor and his wife employed him primarily to look after their two teenage sons but also used him for household chores, one of which was making and serving drinks at cocktail hour.

The Wittmer house where John lived for four months was, and still is, a magnificent Tudor-style house on the Great South Bay on the east side of Brown's River at 72 Oak Road in Bayport. John stayed with the Wittmer family for the summer months following his 1940 high school graduation and just before moving in with Hank in a small apartment in Newport News, Virginia.

Betty said that the Wittmers, who were friends of her parents, originally summered at the much smaller house on the southwest corner of Foster Avenue and Elm Street in Sayville. In the late 1930s, Dr. Wittmer had the Tudor mansion custom built. But the wealthy and respected family met with misfortune not long after moving into their new home. The doctor passed away suddenly from a heart attack. Heartbroken from the tragedy, Mrs. Wittmer returned to living full time in an apartment in Brooklyn; what happened to their two sons no one seems to know. One wonders if John ever realized the irony of the story of the unfortunate Wittmer family juxtaposed against the success story of the Cottages family.

One can imagine how John must have felt working for the wealthy Dr. Wittmer and minding his two financially fortunate sons while dating the well-to-do Betty Catlin. Betty and the Wittmers introduced him to a milieu far more moneyed and advantaged than his own. Here was a world he

had never known—wealth, influence and privilege—a lifestyle and situation he had only dreamed of for himself.

Betty's family (father John B. Catlin, mother Helen Robb Catlin and younger brother John Jr.) spent the summer months in a comfortable house at 127 Gillette Avenue in Sayville. Winters were spent in a lovely house at 568 Fourth Street in Brooklyn. John Jr. attended Brooklyn's venerable, all-male Polytechnic Preparatory Country Day School, while Betty attended Brooklyn's Berkeley Institute (now the Berkeley Carroll School), chartered by New York State in 1886 as a private school for the education of young ladies, located at 181 Lincoln Place in Brooklyn.

The four Whitehouse children appearing all grown up. The photo probably was taken in front of the Cottages on the occasion of John's high school graduation in June 1940.

The Berkeley Institute, as the crow flies, is only a mile or so from the site of the Church Charity Foundation's Brooklyn Orphan's Home. Also, while the Berkeley Institute is proudly nonsectarian, it, too, had an Irish connection. The school was begun by Reverend Alfred Roe in 1883 and named for Anglican Bishop George Berkeley, the influential Irish American empiricist philosopher of the eighteenth century.

Betty often recalled how her parents, John and Helen Catlin, wanted her to date the moneyed young men she met at the fancy parties and cotillions in New York City but how she only wanted her "Johnny." It doesn't take much imagination to conjure up some of the exchanges that must have taken place between teenage Betty and her parents on the potential benefits of becoming interested in someone other than the orphan "Johnny," someone with a much better pedigree and a far more guaranteed future. But no amount of coaxing and cajoling from concerned parents would change her mind. Betty rightly described her relationship and eventual marriage with John as a union of opposites, saying that the marriage worked so well for all those

years because of it. For John, the opportunity to marry Betty was a classic Cinderella story; it meant the opportunity to leave poverty and loneliness behind for wealth, a family and a far brighter future.

John's childhood background of being "underprivileged"—although this relatively modern term seems not entirely appropriate—remained with him all his life, influencing many of his actions, decisions and relationships. How could it be otherwise? A child who has experienced destitution—especially a child who also loses both loving parents at an early age—could never be expected to leave that experience completely behind. However—and much to his great credit—no one recalls John ever openly citing his childhood or his upbringing as being better or worse than that of anyone else. Similarly, older brother Hank also found no need to dwell on his youth or the Cottages experience, providing stories about his childhood only late in life and always with prodding. Hank once said that the only thing that ever bothered him about growing up at the Cottages was knowing that the Sayville School Board demanded tuition from the CCF because it did not consider him and the other children to be citizens of Sayville.

After graduating from Sayville High School in 1937, Hank set about earning as much money as possible to pay for his higher education. During the summer of 1937, he worked as an orderly at the huge and now closed Central Islip Psychiatric Center complex. Hank commented that the primary reason why he, and so many of the other inmates, took jobs in the nursing field was not because they loved nursing but because in the late 1930s that was one of the few professions with job openings.

Another employment possibility for Cottages children was the U.S. military. Milton J. McGlynn, who graduated from Sayville High School in 1937, joined the U.S. Army Air Force later the same year. According to Islip Town records, during World War II McGlynn served in the South Pacific, India and China with the Fourteenth Air Force. Among other decorations, he was awarded the Bronze Star with two stars. In December 1945, he returned to the United States and immediately reenlisted to go back overseas. Herb Jemott, who also grew up at the Cottages, became a serviceman. Hank commented that he last saw Jemott in the early 1950s, and at that time he was a pilot and a lieutenant colonel in the U.S. Air Force.

In September 1937, Hank moved to the Tidewater Virginia area to begin his freshman year at William and Mary. To help pay his tuition bills—about $700 per year—he went after a scholarship as a walk-on with the school's football team. He did well enough on the gridiron to receive a $100 per year scholarship for the remainder of his undergraduate education.

Following his first year in college, starting in the summer of 1938, Hank went to work at Newport News Shipbuilding and Drydock Company (now Northrop Grumman Newport News) as a ship fitter. Because of his physical size and strength, the company put him to work swinging a sledgehammer, bending into place steel girders that functioned as ships' bulkheads—the ribs of the ship. By the end of the first day, he could barely open and close his hands. But the money was good, so he stuck to it. In old age, his hands became almost paralyzed with arthritis, a condition he blamed on those long-ago hours of beating steel with that big hammer.

Hank continued with his studies, and his summertime work with Newport News Shipbuilding, eventually graduating in June 1942 from the college's five-year jurisprudence program. At William and Mary, he met fellow student Frances Knight, a beautiful and intelligent southern belle, whom he married on December 20, 1941, less than three weeks after Pearl Harbor and not long before his graduation.

Hank first learned of the College of William and Mary from Mary Erhard. She had vacationed in Virginia, visited Williamsburg and fallen in love with the beautiful buildings and grounds of the nation's second oldest college. Mrs. Erhard had also convinced Herbert Jemott, who was about five years older than Hank, to attend William and Mary. The two saw each other socially while at the college.

Not long after high school graduation and his summer with the Wittmers, John followed big brother Hank to Newport News Shipbuilding and Drydock Company to take a job as an apprentice ship fitter. From October 1940 to August 1942, he worked and saved his money, traveling to Brooklyn when he could to see Betty. John wrote in official U.S. Navy documents completed during his navy induction process that by the time he left Newport News, he was supervising thirty-five other ship fitters. Hank said that John, and eventually Gil as well, lived with him and Frances at 626 North Ellen Road in Hilton Village, Virginia, just outside Newport News. Gil also went to work as a ship fitter; in fact, in the summertime everyone except Hank's tolerant wife, Frances, was working various shifts in the shipyard.

What was Betty doing at this time? Following graduation from the Berkeley Institute in June 1940, she enjoyed the summer dating John. The two of them loved to go to Fire Island, often to a place called Fisherman's Path, now a boardwalk address in the eastern part of Fire Island Pines near where the original sand path was located. The two also liked to visit the ancient and beautiful Sunken Forest, a forest of low-growth vegetation sandwiched in the swale between the ocean dunes and the Great South Bay. Years later, Betty's family regretted not holding

on to the bay-front lot near the east side of the Pines harbor that John B. Catlin purchased in the early 1950s for the then outrageous sum of $500. In the bigger family financial picture, John B. Catlin's early death in 1952 would mean a huge financial loss for the family over the coming decades.

In September 1940, Betty started her freshman year as a full-time student at New York University while living at home in the spacious and servant-attended town house at 24 Prospect Park West in Brooklyn. Her father had moved the family to this new residence that year following the departure of an elderly aunt for more manageable quarters. Little did Betty know when she started at NYU that her graduation almost four years later would come on D-Day: June 6, 1944. She graduated cum laude with a degree, she says, in "science and physical education." She points out that because graduation was on D-Day, almost no one went to the ceremonies; everyone was at home listening to news from Europe.

The Catlin town house at 24 Prospect Park West in Brooklyn was reminiscent of Old World splendor. It had a beautiful wooden staircase with lush red carpeting and a wide banister just perfect for a child of any age to slide down. The dining room was oak paneled, with a huge mahogany dining table overseen by the well-dusted, stuffed head of what had once been a singularly large moose. Teddy Roosevelt would have been proud of having shot it.

Even into the late 1940s, the Brooklyn town house was a family treasure. Betty and John, together with their son, John Jr.—then three years old—lived there. Every morning, one of the "Norwegian help" would make a large stack of buttered raisin toast. (Helen Robb Catlin, eventually Helen Robb Bond, referred to her servants collectively as "the help." Even at an advanced age, she liked to tell people she only used Norwegian help because they were the cleanest.) The cook would have the maid deliver the stack of raisin bread to the dining room table, with the top slice prominently displaying a large, juicy raisin. Master Jackie—as the help were told to refer to John Jr.—was then invited to pluck and consume the prominent raisin treat, to the smiles and applause of the assembled help. Master Jackie has loved raisin bread toast ever since.

What a far cry from Mary Erhard's standard breakfast fare of homemade porridge doled out at the Cottages. One might wonder why John allowed John Jr. to be indulged in such a fashion, but probably he didn't have a choice. A poor man marrying into money, and living with his in-laws, does not usually enjoy dominance or even much influence in family decision-making.

Everyone in the John Whitehouse family now rues the day in circa late 1949 that the family town house on Prospect Park West was sold. But what

they often forget is that John B. Catlin used the money from the sale of the Brooklyn property to build the beautiful waterfront home at 70 Sunset Drive in Sayville and for other substantive investments from which some in the family would benefit greatly in decades to come. Some of the money also went for "toys" for the new Sunset Drive house, such as two brand-new 1949 Buick Roadmasters. One was a large and stately two-tone four-door sedan, with a cream-color top and navy blue body, and the other a flashy pearl gray convertible. Then there was the forty-foot ketch named the *Sea Dawn* to tie up at the new bulkhead in the backyard. The boat was beautiful but drew far too much water to sail comfortably in much of the shallow Great South Bay. For example, on day trips to Cherry Grove it often bumped across the bottom, much to the delight of the children.

So what happened to Henry and Anna Whitehouse's youngest child, and only daughter, Mary? After graduation from Sayville High School in June 1942, Mary went on to nursing school at Lenox Hill Hospital at 100 East Seventy-seventh Street in Manhattan. Mary's daughter Lucy comments that at some point during World War II, Mary also worked as a volunteer for the U.S. Navy. In what capacity or for how long Mary did this is not known.

But let's return to the time not long after life at the Cottages and just before World War II. In late 1941, Hank received a letter from his draft board saying his country needed him. By this time, his bosses at Newport News Shipbuilding considered him an essential employee. One day, his primary boss approached him and told him not to worry about the draft; the company would submit the requisite paperwork to secure for him a deferment based on defense industry requirements. But Hank ignored the offer, talked to the army and decided he would enlist anyway.

According to Betty, not long after Pearl Harbor the draft board was also pursuing Gil, who felt he should join the war effort. Meanwhile, the draft board declared John 4F due to the knee injury he had suffered during his high school football days. But with Hank and Gil headed for the service, John decided to ignore his 4F classification. As with so many other young men of the time, John and his younger brother Gil decided to do the right thing—what was expected of them by their Sayville family and what they expected of one another. Together, John and Gil enlisted, volunteering for the navy's aviation cadet program.

By war's end, many local men had served in uniform. The Friday, July 21, 1944 edition of *The Suffolk County News* said, "Sayville has 527 residents in the armed forces as of June 16, 1944." West Sayville had another 147 and Bayport had 182.

JOIN THE NAVY AND FLY

In June 1939, the United States Navy had only 1,248 active duty navy and marine corps pilots. But with the outbreak of World War II, and the almost immediate shift in tactics away from battleships and toward airplanes, the navy needed more pilots—and fast. Between 1941 and the end of the war, the navy trained approximately 65,000 pilots, including John and Gil.

The two young men were part of the same navy program, entering on duty in August 1942. Hank confirmed that in August 1942, John and Gil went to Roanoke College in western Virginia for an initial training regimen prior to entering the naval aviation cadet program. Roanoke College was, and is, a private four-year institution located in the town of Salem, Virginia, just outside the larger city of Roanoke.

What John and Gil studied and where they lived while enrolled in the Roanoke program is uncertain, but their "college years" turned into college months. Both John and Gil left Roanoke only about four months after getting there. Neither man would ever again return to a college environment.

John's service jacket shows that he began boot camp training in December 1942, completing his basic training in February 1943. Unofficial records show that Gil completed the same program. Then, from March 1943 to July 1943, both young men were aviation cadet trainees in Norman, Oklahoma. Following graduation from the trainee program, Gil and John became full-fledged aviation cadets stationed at the Naval Air Training Center in Corpus Christi, Texas.

John had lots of stories about the navy flight training in Texas. A few of them involved the initial basic trainer aircraft the navy used to get neophyte pilots off the ground and familiar with flight. Most of the prospective pilots, including John and Gil, had never flown before, so they needed experience with

something fairly slow moving and reliable. For that purpose, the Naval Aircraft Factory in Philadelphia, Pennsylvania, produced the N3N-3 Canary—semi-officially known as the "Yellow Peril"—a cloth-covered, two-seater biplane. It was to be the last biplane in U.S. military service.

The N3N earned its "Yellow Peril" moniker primarily because of its bright yellow paint job but also because it had its share of accidents, in part due to the level of competence of those flying it. It also had a nasty tendency to "ground loop" if the landing were not done just right. The plane had other drawbacks, including a difficult starting procedure that required the hand cranking of an inertia

Gil on the Roanoke College campus. The photo was taken in the late fall of 1942.

flywheel until enough momentum was achieved to be able to pull the engine start handle. Another problem was the inability of the student pilot and the instructor to communicate clearly after takeoff. Because of the rush of the wind in the open fore and aft cockpit, hearing was difficult at best. John used to say he once almost fell out of the cockpit during one in-flight maneuver.

Student pilots completed about one hundred hours in the N3Ns before moving up to a single-wing, higher-performance aircraft and training that would lead to landing a plane on a pitching carrier deck, which is still a requirement for all U.S. Naval aviators. The landing requires a mental toughness that not everyone possesses. Make a mistake and it can be very costly.

On November 24, 1943, Gil's service as an enlisted man was terminated when he was awarded his gold wings. He then accepted his commission as an ensign in the U.S. Naval Reserve, effective from November 16, 1943. Seventeen days later, on December 11, 1943, John earned his wings as a U.S. Navy pilot and his commission as an ensign in the USNR. In the navy, much

has always been made of the date of someone's rank, not so much at the lower grades but more so as people become senior. Gil outranked John, if only by one month, but still a fact that younger brother Gil enjoyed kidding him about.

Hank related a story about Gil that illustrates how an attempt to save someone from his own mistake can sometimes lead to a much greater tragedy for that person. Hank explained that the Newport News shipbuilding firm paid its employees in silver dollars for any overtime worked, so he, John and Gil collected their silver dollars in a kitchen coffee can. One day Gil, who at the time apparently did not understand that you could not pay a bill by writing a check on your savings account, got in trouble with the navy for bouncing checks. The navy took such a dim view of Gil's actions that he was to be dismissed from the naval aviation cadet-training program for cause. But Frances, Hank and John rushed to his rescue, taking their silver dollar collection to the bank to clear up the financial misunderstanding, thereby saving Gil's naval aviation career. If the trio had left Gil's financial mistake alone, and Gil had been dismissed from the aviation program, then the future might have been much different.

From December 1943 to February 1944, John was in pilot training at a naval air station called Cecil Field in Jacksonville, Florida. In March 1944, he began Landing Signal Officer School. A landing signal officer (LSO) had the job of standing on an exposed platform on the port quarter of the carrier flight deck and directing incoming pilots to a safe landing. The LSO also told the pilot making the landing when to cut his engine to allow the plane to fall to the ship's deck. Landing on a flight deck is like a controlled crash, so the job of the LSO requires decisiveness, excellent judgment and superior hand-eye coordination. Make a mistake and people could die.

John's lengthy LSO training lasted until July 1944, when he received orders to report to Brown Field as an assistant LSO. Brown Field is located in Otey Mesa in southern California, about sixteen miles south of NAS North Island in San Diego, very close to the Mexican border. John brought his young bride Betty to live in Chula Vista, located just south of San Diego, where the two partied with other pilots and their wives and girlfriends every available night until John's deployment ninety days later in October 1944.

A San Diego landmark for every western Pacific sailor since before World War II is the U.S. Grant Hotel located in the heart of downtown. Built in 1910, it is a splendid place with all the gilded grandeur of the best of the fine old hotels. Betty and John stayed there in 1944; Gil probably went there; John and Betty's son Jack and his wife Elaine spent the second and third nights of their married lives there; and their son, John III, attended navy and

The Cottages of St. Ann's

John demonstrating use of the landing signal officer's paddles in bringing an aircraft in for a landing aboard the USS *Lunga Point* (CVE-94). The material on the paddles was international (very bright) pink.

marine corps balls at the now completely refurbished hotel. To be there is to experience a sense of the love felt by all those who reunited there after very long separations. It also stands as a reminder of all those thousands of brave men and women who spent their last nights together underneath its roof, saying goodbye before long separations or, for many, saying goodbye forever. If ever ghosts inhabited a building, they must exist in this lovely old hotel.

Betty recounts that her wedding to John was scheduled for a date in June 1944. They picked the date because the flight group to which John had been assigned as an LSO had leave (military vacation) for the entire month prior to deployment. But in early June, John contracted the measles. His measles meant two very important things: his wedding had to be postponed until July, and his training group had to leave him behind for a later deployment with another ship and air group. Betty says it was the luckiest thing that ever happened because the ship and squadron to which he was assigned before coming down with the measles were lost in combat.

THE FAMILY'S
TWENTY-ONE-YEAR-OLD
HERO

The way John used to tell the story years ago, on the evening of Friday, March 24, 1944, he was sitting at his desk in his dormitory room at Naval Air Station Jacksonville writing a letter. Then, for no apparent reason, a picture of his brother Gil suddenly fell off his desk to the floor. John insisted that he knew in that instant that Gil was dead. Several hours later, the navy informed him that Gil had been killed in a training accident.

A footnote to this story is that John was neither superstitious nor a believer in paranormal events, but he swore to this story. It is also curious to note that NAS Jacksonville is on the edge of what is today known as the Bermuda Triangle. Less than two years after John's incident, five Navy Avenger torpedo bombers, known as Flight 19, would take off from NAS Fort Lauderdale and never be seen or heard from again.

The accident that killed twenty-one-year-old Gilbert Whitehouse happened in the waning light of a late March afternoon as Gil was bringing his plane in for a landing at the U.S. Naval Air Station, Alameda, California. Gil was piloting a carrier landing–capable SNJ Texan used at the time by the navy for advanced training and scouting missions. (Under the U.S. Navy's pre-1962 aircraft designation system, the designation SNJ stood for a scout-trainer type of aircraft made by North American Aviation Inc.) Gil's destination, Alameda Naval Air Station, located about five miles due east of San Francisco, closed for good in 1997.

According to Gil's U.S. Navy–provided Certificate of Death, his plane "was struck by a [*sic*] F6F. The propeller of the latter plane cutting off the tail of the SNJ. The SNJ 'spun' to the ground. This occurred at 1432, 24 March 1944." The death certificate further states that there was no negligence on Gil's part and that the accident occurred during an authorized flight. Gil's

death certificate indicates the cause of his death to be multiple and severe injuries to his head, chest and legs.

Hank, John and others have provided information that indicates the weather was clear that day, but the pilot who hit Gil's plane was in a hurry to get home and didn't take the time to make sure the air space around him was clear of other air traffic. A news clipping of the incident says that Gil had an air crew man, a radioman named Charles Hobbe, in the seat behind him. This individual was also killed when the plane hit the ground. John said he tried to learn the identity of the pilot who had been responsible for Gil's death, but the navy refused to tell him.

Gil was buried in Arlington National Cemetery with full military honors, including a flyover by a group of navy aircraft. Since the Civil War and the origination of Arlington National Cemetery, he is one of only 240,000 other heroes who have been so honored with interment there. His simple white gravestone stands on a small hill, one of a sea of others spreading out over the expansive grounds. Every hour, a changing of the guard ceremony takes place at the Tomb of the Unknown Soldier. There is such great poignancy in watching the remarkably silent and precise ceremony and the hushed reaction of those in the crowd.

Betty remembers vividly Gil's burial on a beautiful early spring morning in Washington, D.C. She said she can never forget the "Navy Hymn" being played as the coffin containing Gil's body was brought to its final resting place by the horse-drawn caisson and full U.S. military honor guard. The stirring music was overpowering in the emotion of the moment, as was the playing of "Taps" after the gun salute. As she said, "Hank and your father, both in full dress uniform, maintained their composure, but how they were able to do it I will never know."

The "Navy Hymn" has long been special to people in the U.S. Navy. In 1860, schoolmaster and Church of England clergyman the Reverend William Whiting wrote the words to the hymn. One year later, in 1861, the words were adapted to the music by another English clergyman, the Reverend John B. Dykes.

The words to the hymn, entitled "Eternal Father, Strong to Save," have been changed and added to numerous times since the original hymn was published in 1861. The first verse of the original hymn is as follows and is included as a tribute to Gil and all the other men and women who have made such a great sacrifice:

Eternal Father, Strong to save,
Whose arm hath bound the restless wave,
Who bid'st the mighty Ocean deep

Its own appointed limits keep;
O hear us when we cry to thee,
for those in peril on the sea.

"Eternal Father" was the favorite hymn of President Franklin D. Roosevelt, who served as U.S. assistant secretary of the navy from 1913 to 1920, and it was sung at his funeral at Hyde Park, New York, in April 1945. This hymn was also played as President John F. Kennedy's body was carried up the steps of the capitol to lie in state. Most will remember that he was a navy lieutenant and captain of PT-109.

Hank said that former Cottages superintendent Marie Louise Levering received the American flag taken that day at Arlington from the top of Gil's coffin. She told them she planned to fly it from a building in Washington, D.C., where she had gotten a position providing assistance to other children in need.

Gil's 1941 Sayville yearbook lists his school activities. He was president of his class in 1940 and 1941; class vice-president in 1938 and 1939; vice-president of the student government in 1940; member of the varsity track team in 1939, 1940 and 1941; and member of the varsity cross-country team in 1940 and 1941. He was also an associate editor of the yearbook.

Beverly Woolley, a pretty Sayville High School classmate, was Gil's high school sweetheart. Betty says she and John went out together with them on several occasions. Their 1941 yearbook shows her activities centered on music and writing. Betty adds that before he dated Beverly Gil went out with Eunice McGlynn, today Mickey Walker, a very pretty blonde girl who grew up with him at the Cottages.

As mentioned before, Gil was a high school track star. In 1941, at the Suffolk County track meet, where more than thirty schools participated, Gil high jumped six feet, two and a quarter inches, setting the Long Island high jump record, a record that remained for decades. The yearbook says he "regularly placed 1st or 2nd in cross country tournaments and placed 4th in the Suffolk County meet." He had a gazelle-like stride made possible by those long arms and legs, and watching him run was said to be worth the price of admission.

But probably the best description of Gil is contained in a two-sentence description next to his photo in his senior yearbook. It says, "Who has not felt the warmth of Gil's smile? Gil, our class president, who is at the same time the athlete and perfect gentleman."

The tragedy is in what could have been; the family members the Whitehouses will never know. Like so many young men of his time, and that war, he was one of the best and the brightest. He was only twenty-one when he died for his country.

REPORTING FOR
DUTY, SIR!

"Reporting for duty, sir." These are the very first words any naval officer utters on coming on board his assigned ship for the first time. The long-established tradition for reporting aboard a U.S. Navy ship is quite formal. As he reaches the top of the gangway, the new officer stops and faces the national ensign and salutes. After completing this salute, he salutes the officer of the deck (OOD), who is standing right in front of him on the quarterdeck. As he salutes the OOD he says, "Reporting for duty, sir. Request permission to come aboard." The OOD returns the salute saying, "Permission granted."

John reported aboard the USS *Lunga Point* (CVE-94) on the morning of Friday, August 27, 1944, as the ship's assistant landing signal officer. Reporting aboard one's first U.S. Navy ship is both exciting and challenging. For John, it must also have been intimidating. He would need to prove himself to his shipmates and to the squadron pilots he would be helping land aboard ship. He would have been concerned about the upcoming cruise into the Pacific war zone and whether he would measure up in real combat situations. And not only did he have those burdens to cope with, but there was also the coming loneliness of having to leave his young wife behind. Finally, he also had to cope with the depression of losing his younger brother, and perhaps closest family member, only six months before.

The USS *Lunga Point* (CVE-94) was a Casablanca class carrier with a single flight deck, only 512 feet long—about half the length of the attack carriers of today. The *Lunga Point* was capable of a top speed of a little over twenty knots and had a displacement of only 7,800 tons. The name "Lunga Point" comes from a feature of land on the island of Guadalcanal, part of

the Solomon Islands in the western Pacific. Lunga Point was the landing site for the U.S. Marines on August 7, 1942, prior to their turning-point victory over the Japanese forces holding the island.

CVEs were nicknamed "jeep carriers" and "baby flat tops" because of their relatively small size and capabilities, but they would prove themselves to be excellent weapons against the Japanese forces both ashore and at sea. The ships were used in the Atlantic as well as the Pacific and proved equally effective in both theaters. The navy also employed much bigger attack carriers (CVAs), often in concert with the smaller CVEs.

The CVEs were sometimes referred to, less kindly, as "Kaiser's Koffins" because of the speed with which the Kaiser Steel Corporation built them. According to the Naval Historical Center, between July 8, 1943, and July 8, 1944, Kaiser Shipyards in Vancouver, Washington, built and delivered to the navy fifty Casablanca Class CVEs. CVE-94 was one of those fifty ships.

The *Lunga Point* was commissioned, or officially entered into service, in mid-May 1944 and was immediately tasked with troop and aircraft transport. It then returned to San Diego, where it took aboard the air group it would carry into most of the war, VC-85. Composite Squadron 85 consisted of about thirty planes, the normal complement for a CVE. John would work as an integral part of that air group, flying its planes and landing its pilots, but officially he was part of the ship's company and not a squadron officer.

So for John, only seven weeks after reporting aboard, at precisely 3:27 on Monday afternoon, October 16, 1944, the USS *Lunga Point* departed San Diego harbor for the western Pacific. You can imagine the day before, a quiet Sunday and John's twenty-third birthday. How did he and Betty spend those final hours? People in such situations count the minutes, thinking there are still eight hours left, or six hours left, or we still have time for one more beer, waiting unrealistically for something miraculous to happen to make the separation never come. While surely sad at leaving his loved ones behind, deep inside John was also eager to get it on and get it over, one way or the other. In some ways it was worse for Betty, as it always is for the military spouse. She had to endure that deep, visceral feeling of loneliness that comes only to the one left behind.

Once underway from San Diego, the ship became part of Carrier Division 29, consisting of the *Lunga Point*, the USS *Makin Island* (CVE-93), the USS *Bismarck Sea* (CVE-95) and the USS *Salamaua* (CVE-96). The sailors didn't know it at the time, but one of these four ships, the *Bismarck Sea*, and many of its crew would not return.

The first stop for every navy ship on its way to the western Pacific was Pearl Harbor. It is one of the world's most beautiful ports, with lush green

foliage on warm brown hillsides rising up from crystal waters to clear blue skies. The natural color combinations are strikingly unique. The lovely island chain lies about 2,500 miles from San Diego in one of the greatest expanses of ocean without land in the world. But John had more than the scenery to look forward to. He had a friend in Hawaii: his brother Hank.

Hank said that he served with the U.S. Army in Hawaii for about the last two years of the war. He had joined the army in August 1943, taking his basic training in New Orleans at an army base near Lake Pontchartrain. After basic, he went back to the New York area and was assigned briefly to Camp Upton, now Brookhaven National Laboratory, where he awaited further orders.

Camp Upton was named after Civil War Union Army General Emory Upton. The camp came into being in 1917 to train soldiers for World War I. One of the trainees was the famous American composer Irving Berlin, who penned the musical *Yip, Yip Yaphank*, which years later became a movie starring future President Ronald Reagan. Another Camp Upton trainee was Alvin York, who would become the most decorated American soldier in World War I. Following World War I, the camp demobilized, with a number of the buildings moved to Cherry Grove, Fire Island. The base then became Upton National Forest until 1940 and the beginning of the U.S. mobilization for World War II. In 1946, the camp closed for a second time, becoming the site of Brookhaven National Laboratory. To this day, lab personnel occasionally come across live ammunition left over from the days of U.S. Army's Camp Upton.

Hank said he chose joining the army over the navy for a number of reasons. First, the draft board had sent him a letter in 1941 "inviting" him to join the service. Because of his younger brothers, he had looked into joining the navy, but his eyesight was so poor the navy told him he would have to take a job ashore. Hank also had a long talk with an army recruiter who convinced him the army offered the most of what he wanted in military service. He said his bosses at the shipbuilding company were furious when they found out that he had enlisted, but there was nothing they could do about it.

John commented that the reason Hank enlisted in the army and did not apply for an officer program was because Hank felt strongly about not wanting any special privilege because of his education or employment. Hank wanted to take his chances serving his country in the same way as those he felt were less privileged than he. John said he thought Hank was "nuts" for feeling the way he did and not signing up for an officer's program, but if pressed, John would admit to being proud of his older brother's actions.

The above illustrates something of how the two brothers lived at opposite ends of the political spectrum. All his life Hank was a liberal, or progressive or Democrat, or whatever the current word may be, on virtually every issue, while younger brother John was a conservative or Republican on the same issues. Yet as children they experienced so much together: the loss of their parents, life as orphans and having only one another and younger siblings as family. One could expect they might see issues similarly, but they did not. It was as though they had come into this world hardwired for their separate beliefs.

The way Hank tells it, the army decided that because he was from Long Island and lived near the water, he must know something about boats, so it made sense to assign him to one of the army's Air/Sea Rescue boats in Hawaii. Undoubtedly, the assignment also had to do with Hank's intelligence and the fact that he was a graduate of William and Mary's jurisprudence program, as well as the fact that he knew something about the water.

During the war, Hank commanded the army's Air/Sea Rescue Boat 679 with a crew of seven men. Hank said the boat was sixty-three feet long and looked much like a PT boat. He added that on several occasions he did take out the army general in charge of the U.S. Army Air Transport Command, but at no time did he take out any navy admirals on fishing trips, as John had always insisted he spent his time doing.

A couple of final notes about Hawaii: in the early 1940s the U.S. military considered Hawaii an overseas assignment. Also, John and his shipmates were very surprised to find that most of the barbers in Hawaii were women. For many sailors, it was the first time they had ever had their hair cut by a female—a good example of how times change in small ways.

INTO COMBAT

O n October 25, 1944, the four ships of CarDiv 29 set sail from Pearl Harbor bound for the atoll of Eniwetok in the northwest Marshall Islands. An aide to *Lunga Point*'s executive officer (the officer second in command aboard a navy ship) wrote about the occasion in early November 1944, as the ship entered the combat zone:

> *Enough of our planes had already been launched and recovered by us to convince us that our pilots were able to handle any mission assigned them. We had also seen them operate enough to know that our LSO, Lt. (j.g.) H.D. Hatcher, and his assistant Lt. (j.g.) [actually Ensign] John Whitehouse, were to be largely responsible for the very small number of flight deck crashes on our ship as compared with the number of such crashes customarily expected.*

From Eniwetok, the ship sailed to Ulithi Atoll in the Western Carolines, where some of the crew made a special trip ashore. The sole purpose of the trip ashore was to gather a sufficient quantity of fine sand to please "Porthole," Captain Washburn's cat. Porthole had run out of sand and in the heat of the tropics…well, you get the picture.

What was the crew thinking at this point, as both Election Day and Veteran's Day approached? One officer wrote, "We found ourselves in strange waters, anxious to prove the results of our long training and determined to do our utmost to prosecute the war to a successful conclusion, and bring about another Armistice Day that would be more significant and lasting than that of 11 November 1918."

In the fall of 1944, sailors aboard the *Lunga Point* did what they could to follow the presidential election that pitted Commander in Chief and three-term President Franklin D. Roosevelt against popular New York Governor Thomas Dewey. Roosevelt, who was sixty-two years old in 1944, seemed much older than his years. The stresses of office, his paralysis, high blood pressure and a lifelong smoking habit caused those close to him to worry that he would not live through a fourth term. Historians say that in 1944 Roosevelt's failing health caused the leadership of the Democratic Party to insist that he replace his vice president, Henry A. Wallace, a man many considered too pro-Soviet. Little-known Senator Harry S Truman of Missouri became Roosevelt's running mate. Roosevelt and Truman went on to win the 1944 election, doing so with 53 percent of the vote. Roosevelt would be dead less than six months after the election.

From Ulithi, the ship and its division joined General Douglas MacArthur's ongoing invasion of the Philippine island of Leyte, providing cover for ship convoys. The island of Leyte and the Leyte Gulf are just north of the Philippine island of Mindanao. In fierce fighting, the American navy had just defeated the Japanese navy at the famous naval battle of Leyte Gulf that had raged from October 21 to 26. But despite the U.S. victory, Japanese forces remained in the area and in force.

In November 1944, the *Lunga Point* operated in the same Philippines battle area as the USS *San Jacinto* (CVL-30), the carrier on which future President George Herbert Walker Bush was serving as a pilot. The *San Jacinto* was a bigger ship than the *Lunga Point*, 622 feet long as opposed to 512 feet, but similar in appearance. The future president flew TBMs and was part of Torpedo Squadron 51 (VT-51).

At 0952 on Tuesday, November 21, the *Lunga Point* came under hostile fire for the first time from a lone Japanese fighter aircraft. There was no damage. But on November 25, in a midair collision of two torpedo bombers, the ship lost one pilot and two air crew men. These men were to be the first of a number of the ship's combat-related deaths.

On November 26, the *Lunga Point* and its division sailed south toward the Admiralty Islands, crossed the equator and, despite the war, celebrated the ancient naval tradition associated with "crossing the line." The occasion calls for those who have not previously crossed the equator (pollywogs) to pay humble—some would use the word humiliating—obeisance to the great King Neptune. On crossing the line, King Neptune inevitably takes human form, usually that of one of the fattest men aboard ship. Among other tasks, the good king demands in great ceremony that his heavily greased

belly be kissed by each pollywog. John would have been a pollywog, but he never mentioned any of the abuse he must have suffered at the hands of the veteran line crossers known as "shellbacks." However, for decades afterward he carried a small card in his wallet proving he had crossed the line and was an official "shellback." Hank says he believes he did this as a "just in case" he ever had to cross the line again.

The "fun" did not last long. The heat and humidity at the equator just north of New Guinea made life in the ship's spaces very difficult. There was no air conditioning. Nearly everyone suffered from heat rash.

On November 27 the ship anchored near the island of Manus, where everyone aboard was overjoyed finally to receive mail from home. It was their first mail since leaving San Diego six weeks before. How happy John must have been to receive mail from his wife in Brooklyn! In John's day, and even through the Vietnam War, there were no computers or satellites and nothing even resembling e-mail, and phone service in most of the western Pacific was virtually nonexistent.

Getting mail was always a very happy moment. Betty probably told him about how she had begun her new job at the Berkeley Institute in Brooklyn teaching biology to ninth graders and some physical education classes for elementary school boys. She says the Berkeley school leadership was very considerate. They offered her a teaching job out of kindness because her husband was in the war. Like so many war brides, Betty still has the letters her husband sent her. John's letters are remarkably uninformative. All personal mail was read and censored in order to avoid possibly revealing any substantive information to the enemy.

The *Lunga Point* remained in Manus through Christmas, but on December 27, the ship and its division, now called "Escort Carrier Force Pacific" (EsCarForPac), sailed for the Kossol Passage in the Western Caroline Islands, where they anchored for New Year's Eve. Celebration of New Year's Eve was limited to an extra cup of coffee after dinner. The U.S. Navy has long been the only western nation not to allow any alcoholic beverages aboard ship.

The men aboard the *Lunga Point* had no celebratory dinner or entertainment to watch on New Year's Day. Instead, on January 1, 1945, the *Lunga Point* set sail from Kossol Roads for the Lingayen Gulf to participate in the invasion of the main Philippine Island of Luzon—one of the largest seaborne military operations of all time. The *Lunga Point* moved farther south into the Mindanao Sea and then into the Sulu Sea surrounded by hostile forces while taking part in the invasion. The squadron on the *Lunga Point* provided air cover for the beach landings that eventually routed the Japanese occupying force.

On January 4, the ship again came under attack from enemy aircraft. This time the ship's gunners managed to shoot down one Japanese plane. But one of the *Lunga Point*'s sister ships sailing in company, the USS *Ommaney Bay* (CVE-79), was lost to a kamikaze attack.

The very next day, things got even hotter for the ship's squadron, VC-85. On Friday, January 5, a VC-85 pilot downed the squadron's first Japanese aircraft, and another VC-85 pilot sank a Japanese destroyer. This battle for Luzon was the first real combat test for John and the rest of the ship's crew, and they performed very well.

Luzon was important, and not just from a military point of view. On the central west coast of Luzon, not far from the Philippine capital city of Manila, lie the infamous towns of Bataan and Corregidor. These two names will forever be associated with the terrible suffering inflicted on thousands of American and Filipino prisoners of war by the Japanese army. The name Bataan became synonymous with the Death March of April 1942 and the subsequent imprisonment of survivors in Camp O'Donnel. Over the subsequent decades, many of the U.S. sailors who visited the huge Subic Bay Naval Station in the Philippines took the opportunity to visit those two infamous towns. The Subic Bay Naval Station closed permanently in 1992.

On January 17, an accident occurred. In heavy seas, John was bringing in a torpedo-bomber when it crashed on the deck. No one was killed, but the plane literally broke in two just aft of the pilot seat. Landing anything on a moving ship can get tricky in a hurry. With the ship's flight deck rising and falling with the waves, and the light aircraft bouncing in the wind, getting the plane's rubber wheels to meld softly with the wooden flight deck takes great skill, nerves of steel and always a little luck.

The *Lunga Point*'s executive officer wrote after the war "that South China Sea had really been rough since we had been there and it was a real credit to the ability of our entire Air Department, and to our LSO in particular, that our plane handling on the flight deck had been so successful during the operation. How they brought those planes safely down on that flight deck in such heavy seas will always be a mystery to many of us."

This brings us to one of the stories John used to tell, an account as frustrating for the listener as for himself. When he would talk about it at all, he would say that he should have been nominated for a Silver Star but the nominating officer named the wrong man. After John's passing in 2002, Betty said the action happened during combat and involved landing numerous aircraft from another carrier after that carrier was sunk by enemy attack. She said he safely landed one aircraft after another in numbers that

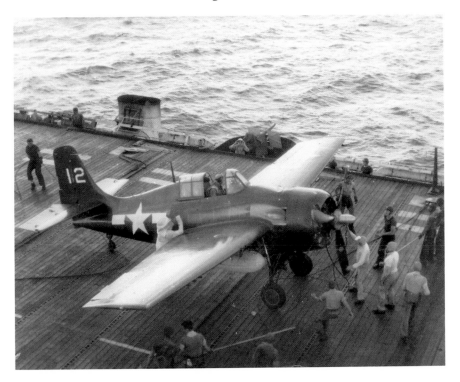

One of the aircraft just after landing aboard the USS *Lunga Point* (CVE-94). The pilot is believed to be John.

filled the hangar deck to the point where several planes had to be pushed into the sea to make room for more incoming. Betty knew no more of the details than that.

As far as is known, there is no written record of the *Lunga Point* ever having undertaken the action described above. That is not to say it did not happen; it simply might not be easily retrievable in a public document. For a prestigious war medal to be awarded, someone has to perform the act, someone has to observe the person performing the act, someone has to take the time to write it up properly and submit it up the chain of command and a board has to approve of the issuance of the medal. Absent one of those things, no medal is awarded, regardless of how brave and self-sacrificing the act. Only one Silver Star was given out on the *Lunga Point* for an act no one could overlook. The navy presented that award to an officer who single-handedly diffused a live bomb on the flight deck after it fell off an incoming aircraft.

THE BATTLE FOR
IWO JIMA

By January 25, the *Lunga Point* was back at Ulithi in the Western Carolines for limited R&R and resupply, but by February 10 it was underway again, this time for the invasion of Iwo Jima, that tiny but tactically important Pacific island with an air base only 660 miles south of Tokyo.

On February 16, VC-85 began bombing and strafing Iwo Jima's military installations in preparation for what would become one of the most famous military invasions of all time. The planes had to soften up their targets before the U.S. Marines' landing, set for February 19. After the battle, the ship's executive officer wrote, "Not only was the taking of Iwo Jima the most costly of the U.S. Marine invasions, but it also provided us with our toughest fight and most narrow escape."

It was during the fight for Iwo Jima that the *Lunga Point* and its crew felt most threatened. The Japanese were all around. The crew knew a torpedo could come bursting through the skin of the ship at any time or that a kamikaze hit could destroy them in a matter of minutes. Their fears were well founded.

On the night of February 21, 1945, the *Lunga Point* came under simultaneous aerial torpedo attack from four kamikaze bombers. Flying at flight deck level, the four planes, one after the other, came at the ship from the starboard beam. John's post for general quarters was at the flight-deck level on the portside stern of the ship, so it is unclear whether he would have seen them coming.

The ship's gunners shot down the first plane, which crashed only about two hundred feet off the starboard side of the ship. The second plane flew away after launching its torpedo. The ship's gunners hit the third plane,

and it fell harmlessly into the sea only about three hundred feet off the starboard side. But the *Lunga Point's* luck ran out with the fourth plane. It hit the flight deck, shearing off its right wing as it slammed into the bridge. The crash sprayed gasoline everywhere, setting fire to the wooden flight deck before the plane mercifully slid into the water off the port side, where it exploded. Flames from the burning airframe severely injured a number of men manning some of the portside gun batteries. John was no more than about one to two hundred feet away from the action, with full view of all that was taking place.

With great effort, the crew was able to extinguish the fires and care for the wounded without further loss. The ship had been very lucky. The four kamikazes had managed to launch a total of three torpedoes, with all three just barely missing the ship. Talk about dodging a bullet—how about dodging four kamikazes and three torpedoes?

Witness to how close the *Lunga Point* came to disaster, during the same battle its sister ship, the USS *Bismarck Sea* (CVE-95) was hit by a single kamikaze while in position only one nautical mile off the *Lunga Point's* starboard quarter. The attack mortally wounded the CVE, and it sank shortly thereafter, with the loss of many of its crew.

Nearby, the much larger carrier the USS *Saratoga* (CV-3) was also damaged. Six Japanese planes hit it within a three-minute period. Its flight deck forward was severely damaged, and it had two holes in its starboard side and at least two large fires in its hangar deck. Then, a short time after being hit by the first six aircraft, it suffered another singleton attack. But by 2015, with the fires under control, the *Saratoga* was able to recover aircraft. However, it had lost 123 men dead or missing, and the damage was such that the ship had to return to the West Coast for repairs.

In Hollywood movies we see a panoramic view of any military action, but for those at general quarters (GQ) stations aboard a U.S. Navy ship, most sailors see nothing of the action. Most of the officers and men are locked into small compartments, usually without ventilation, so as to minimize the chances of being killed by fire, smoke or noxious gases. To spend hours under such conditions, under torpedo and kamikaze attack, took genuine courage for everyone but probably most of all for those below decks. For the crew manning the magazines, engine rooms, boiler rooms, after steering and the like, there is precious little to do except think about what may be coming your way.

Effective March 1, 1945, or only about sixteen months after his commissioning, John was promoted from ensign, or O-1 (the most junior

officer rank) to lieutenant junior grade (Lt. j.g.), or O-2. Such a promotion was pretty much automatic, if not a little bit early, and reflected the fact that John was performing his job well. Tragically, March 1 was also the date one of VC-85's planes was shot down. The plane, its pilot and two air crewmen were lost to enemy anti-aircraft fire somewhere near Iwo Jima.

Japanese anti-aircraft fire was responsible for downing more U.S. Navy planes in the western Pacific than any other cause. Which brings us to another one of John's all too infrequent stories. He told Betty that on one occasion his plane was hit by machine gun fire and that one of the rounds started a fire in the engine of his aircraft. Desperate to get the fire under control, he tried a trick he had heard one of the other pilots use. He put the plane into a steep dive in the hope that the force of the wind would blow out the flames. The action worked, saving him long enough to be able to return safely to the ship.

The ship's executive officer wrote that the taking of Iwo Jima was a turning point in the war because everyone realized that ultimate victory over Japan was now only a matter of time. Could the United States have forced Japan to surrender without using the A-bomb at Hiroshima and Nagasaki? We will never know for certain.

By March 21, 1945, the *Lunga Point* was again underway from Ulithi Atoll on its way to participate in the huge operation to secure Okinawa. Okinawa is another tiny Pacific island, but this one lies in the Japanese Ryukyu Islands chain just off the main Japanese southwest coast.

The invasion was set for Easter Sunday, April 1, which meant the *Lunga Point* and its planes had to begin their attacks several days before, on Good Friday. What does a good, God-fearing Episcopalian think on Good Friday as he sets out to bomb the hell out of his fellow man? It's fairly certain the only thing John was thinking about was getting back safely to his ship. It is often not until months, or even years, later that people think back on what they've done and wonder whether it was right, or could have been done more cleanly, or should have been done at all. At the start of the action, the soldier, sailor or airman is often overtired from long hours on alert, even bored from waiting for something to happen. After months with the boredom and discomfort only occasionally broken up with adrenalin-pumping combat, shooting at an enemy from a distance can become impersonal, even routine.

People who shoot at other people in war—directly or indirectly—days, months, years later think hard about what they have done. Some are bothered by it more than others; some have better coping skills than others. Certainly, John thought about what he had done, but he never let himself be overcome

by it. That may have been a benefit from his attitude going into the war. He used to say he always kept in mind that the poor Japanese guy was just like him, just doing what he could to try to survive. Personal animosity played no role. He said he always kept just one goal in mind, and that was simply to survive whatever came his way.

It took almost ten days to secure the island of Okinawa. During the battle, the *Lunga Point's* VC-85 shot down one more Japanese fighter aircraft, and on April 2, the ship's guns downed at least two more kamikazes in two separate actions. The executive officer wrote, "There had been no time during our combat career that we had been more vulnerable [to attack than on this date]." The ship was at general quarters fighting off enemy aircraft for almost twelve straight hours. The next day, in an unprecedented action, the commander of escort carriers in the Pacific, Admiral C.T. Durgin, flew aboard the *Lunga Point* to personally congratulate the entire crew for their actions the previous day. Then, on April 8, the squadron enjoyed its finest hour, shooting down eight enemy aircraft.

DANGER TO THE END

B y early May 1945, the *Lunga Point* was in Guam for a brief period of rest and recuperation. While there, VC-85 was ordered home and eventually on to further assignment. As a ship's officer, John remained aboard ship. On May 23, a new squadron, VC-98, came aboard as the ship again got underway. The ship proceeded to its assigned operating area in the waters near Okinawa but, on the way, ran into a different kind of trouble. On June 4 and 5, the *Lunga Point* got caught in the middle of a major typhoon. No one got any sleep as the big ship rolled as much as twenty-five degrees and waves continually broke over the bow, some sending green water up and over the flight deck.

Getting caught in a storm such as this is scary even for seasoned sailors on large ships. For men on smaller ships—those that are the size of World War II destroyers and smaller—it can be terrifying. In a major Pacific typhoon, the tops of the waves tower over the masts of the destroyers and green water punches out the windshields on the bridge and rips off weapons and equipment welded in place on the decks. Even at high noon, the darkness from the weather, the wind-driven rain and the spray from the monstrous waves brings visibility to near zero. Sky and sea seem to meld into a single raging entity. The sound of the storm is deafening. Without visible reference points of any kind, sailors on the bridge have great difficulty in determining where their ship is located. It is as though the ship is being swallowed whole in some giant maelstrom. Sailors suffer broken bones and other impact injuries from being tossed around inside the ship in the unpredictable violence of the raging seas.

After two days of battling the violent storm, on June 7, the *Lunga Point* resumed facing the man-made threat of Japanese attack. Their luck

continued to hold, and despite numerous hours at general quarters, not a single kamikaze or other enemy weapon even got close to hitting the ship. By mid- to late June, the *Lunga Point* was sent to the island of Leyte in the Philippines for some welcome shore leave.

In July, the *Lunga Point* took part in an anti-shipping patrol off the coast of mainland China. At one time, it was only about seventy miles off the mouth of the mighty Yangtze River. Planes from VC-98 carried out a number of successful raids against small Japanese craft plying the river before yet another typhoon came along and drove the ship out to deeper water. On this occasion, they were fortunate enough to avoid the storm altogether.

On Friday, August 10, word got to the ship that the Japanese were ready to accept the terms of the Potsdam Ultimatum and that surrender could be expected at any time. Then finally, on Wednesday, August 15, at a little after 0800, the captain of the *Lunga Point* announced to the men under his command that the Japanese had accepted unconditional surrender and that the emperor was to order the immediate cessation of hostilities. John said the cheers were deafening.

The ship then headed for Saipan for a quick overhaul before putting to sea again in early September. Only about one month before the *Lunga Point*'s arrival in Saipan, American forces had liberated the island in extremely heavy fighting. The loss of human life in the three-week-long battle had been horrific. It was the basis for another of John's few stories about the war:

Saipan was the first Japanese-held island American forces encountered that was occupied by a large number of Japanese civilians. Long before the American attack, the Japanese government convinced the people of Saipan that the American forces were monsters and that life with them would be a living hell far worse than death. The Japanese government strongly encouraged the islanders to take up arms in defense of their homes and do everything in their power to resist. In June, the Japanese Imperial Palace went so far as to send the governor of Saipan a message telling him that any Japanese civilian who died fighting the Americans would be granted the same afterlife privileges as a soldier who died in the emperor's service. As a result, thousands of the approximately twenty-two thousand Japanese civilians on Saipan battled the U.S. forces. By July 9, the Americans had pushed the Japanese to the very northern edge of the island. There, thousands of the surviving civilian men, women and children stood atop the high cliffs overlooking the sharp rocks below. Rather than face the American monsters, approximately eight thousand people chose certain death by diving off the cliffs, many clutching babies and small children in their arms.

John said the approach to the airfield on Saipan took the *Lunga Point* pilots over the cliff and rocks where these poor unfortunate people had died. He said the sight and the smell of so many rotting corpses was almost overpowering and would stay with him always.

On September 7, as the *Lunga Point* left Saipan, VC-98 disembarked for reassignment. The space that came free was to be used to assist in transporting Allied prisoners of war held by the Japanese from the Japanese main island ports of Wakayama and Nagasaki.

Wakayama is a southern port city on the main island of Honshu, just south of the ancient city of Kobe. Nagasaki is, and was, a Japanese west coast port city on the southwestern island of Kyushu. While transiting from Saipan to Wakanoura sounds like it should have been easy with the dangers of war over, it was not. The Japanese had extensively mined their inland waterways, and American B-25s had also laid down large minefields. Everyone was nervous about being surprised by a mine explosion. But with some considerable luck, by mid-September the *Lunga Point* was safely anchored in Wakanoura, a lovely coastal suburb of Wakayama.

It was in Wakanoura that John got the chance to spend some time ashore and see a tiny bit of the country for himself. He was required to carry a sidearm when he went ashore, despite the pathetic condition of the surviving Japanese inhabitants. It was a unique experience; many of the people were living in squalid conditions in makeshift shelters. U.S. bombers had devastated many areas, and the Japanese people had been forced to sacrifice almost everything they owned for the war effort.

With all the POWs from Wakayama assigned to other ships before the *Lunga Point*'s arrival, it was ordered to proceed to Nagasaki. John's ship arrived there on September 17, less than six weeks after the August 9 atomic bomb attack that totally destroyed one-third of the city, killing 73,884 people and injuring 74,909 more. Radiation burns and sickness killed many more in the months and years that followed. None of the ship's crew was allowed ashore except on official business, but even the sight from the ship must have been difficult—of Nagasaki only a little over a month after the terrible destruction wrought by a nuclear weapon.

The *Lunga Point* loaded 760 former American POWs into the hangar deck and departed Nagasaki on September 19 bound for Okinawa, where the POWs were disembarked. The executive officer wrote that the stories told by some of the former POWs literally raised the hair on the back of his neck. If John heard any of them, and he must have, he never repeated a word to anyone.

The Cottages of St. Ann's

From September 28 to October 17, the ship was in and out of Wakanoura, but on October 18 the *Lunga Point* anchored in Tokyo Bay. Here, John and his shipmates got to see the Imperial Palace, the Ginza (famous shopping district) and the American Embassy. These scenes must also have been difficult. The citizens of Tokyo had taken the brunt of the horrific last few months of the war. Allied bombs had destroyed 90 percent of businesses and industrial areas of Tokyo and nearby Yokohama.

On October 28, the USS *Lunga Point* left Tokyo harbor bound for San Diego. The ride home was a rough one, with huge seas the entire way to Pearl Harbor. It was so rough that the crew found it almost impossible to stay in their bunks. In addition, the ship was suffering from a fresh water shortage and was short on rations, making the trip very uncomfortable. On November 7, the ship docked at Pearl Harbor, where Hank and John had a chance to meet and exchange a few stories, probably over several Mai Tais that the Hawaiians make so well. The ship left Pearl on November 8, arriving back in San Diego on the morning of November 15, 1945.

RECOGNIZED HEROICS SOON FORGOTTEN

For the actions of his ship, the commanding officer of the *Lunga Point* received the Navy Cross and the Legion of Merit. As previously described, one officer won the Silver Star for disarming a live bomb on deck. A total of seven other officers won the Bronze Star, and twelve officers and men won the Purple Heart. A total of nine officers and enlisted men aboard ship lost their lives in accidents and hostile action between November 25, 1944 and April 6, 1945.

For its service, the USS *Lunga Point* (CVE-94) and its original air group, VC-85, were awarded five battle stars and the prestigious Presidential Unit Citation. Each of the officers and men aboard *Lunga Point* was authorized to wear the Presidential Unit Citation ribbon on his uniform.

The U.S. Presidential Unit Citation is seldom awarded. The Defense Department says it is awarded to units of the armed forces of the United States and allied nations for extraordinary heroism in action against an armed enemy occurring on or after December 7, 1941. The unit, or John's ship in this case, must display such gallantry, determination and *esprit de corps* in accomplishing its mission under extremely difficult and hazardous conditions as to set it apart and above other units participating in the same campaign.

The degree of heroism required for a ship and its crew to receive the Presidential Unit Citation is the same as that which would warrant the award of a Distinguished Service Cross to an individual. The Distinguished Service Cross is the equivalent of the Navy Cross and second only to the Congressional Medal of Honor for individual heroism in combat.

John got back to 24 Prospect Park West in Brooklyn on leave sometime in late December 1945, in time for the holidays with Betty. What a joyous time that must have been! As bad as the leaving is, the return from a long deployment is wonderful, and all the more so in John's case after so many close calls. He stayed in Brooklyn from December through March; his service jacket shows him reporting to a naval air squadron in Pensacola in March 1946.

What happened to the ship after that triumphant return? The USS *Lunga Point* was decommissioned in October 1946 and placed in mothballs in Tacoma, Washington. In April 1960, without ceremony, it was sold and torn apart for scrap.

EPILOGUE

From the Cottages' closing in the summer of 1943 until August 1948, the Church Charity Foundation employed its Sayville buildings for an Episcopal diocese–administered summer camp. The Cottages probably also had some additional utility as extra space for the occasional meeting, church party or for storage of property and records. But by the summer of 1948, the CCF had the Cottages ready for additional humanitarian service.

The Suffolk County News of August 27, 1948, carried a picture of the Right Reverend James P. DeWolfe, Episcopal bishop of the Diocese of Long Island, dedicating the Cottages anew as an Episcopal Home for Boys. The children who were to be part of this second incarnation of the Cottages came from quite different circumstances than the original group. The *News* described the Episcopal Home for Boys as a "haven for underprivileged and wayward boys."

The Home for Boys closed its doors permanently in about 1954 due to a shortage of funding, with the diocese deciding it no longer wanted the property. In 1956, a proposal to use the property for a community center went down to defeat. Finally, in 1959, St. Ann's Church acquired the buildings and property to use for its Sunday school program, thrift shop and records storage.

A *Suffolk County News* article from August 1963 carried Mary Erhard's obituary. It says she was born in Hoboken, New Jersey, in 1884 and was the widow of the Reverend William Joselin Erhard. She traveled widely with her husband in the missionary fields and was the author of many articles on Episcopal Church history and doctrines. She then taught elementary school in New York City for twelve years before becoming superintendent of the

Children's Cottages in Sayville. The piece does not mention what she did in the years from 1935 to 1947, but we know from another news article that in 1936 she went to Charlottesville, Virginia, where she served as a teacher and surrogate mother for fourteen motherless girls at St. Olive's Home. Her obituary concludes by saying she had been a resident of the Eliza Gray Case Home in Swansea, Massachusetts, since 1948 and was survived by two daughters, Constance Segeren of Camden, New Jersey, and Mrs. Gertrude Doherty of Queens Village, and a son, Ronald Erhard of Sayville, as well as nine grandchildren and fourteen great-grandchildren.

The Reverend Joseph H. Bond's first wife, Margaret, a great asset to him and the entire congregation, passed away in 1951. In 1954, he married the wealthy widow Helen Robb Catlin. Their marriage lasted more than thirty years. The pair often traveled abroad, with Reverend Bond particularly enjoying a visit to the Holy Land, the fulfillment of a lifelong dream.

On November 1, 1959, Reverend Bond submitted his resignation as rector of St. Ann's effective May 31, 1960. On June 1, 1960, Reverend Peter D. MacLean became the new rector, with Reverend Bond eventually accepting the title of rector emeritus. The church and community honored Reverend Bond for his long and dedicated service. The church awarded him the Diocesan Service Cross; the Sayville Rotary Club made him guest of honor at a special testimonial program; and 230 people from the Sayville community gave him a testimonial dinner. On December 28, 1984, at the age of ninety-five, the much-loved Reverend Bond passed away in his sleep at 70 Sunset Drive. Reverend Bond is interred in a modestly marked grave in St. Ann's Cemetery.

Marian Levering, who was a nurse by training, eventually went to Korea, where she served in a medical services capacity. What happened to her there, or after that, is unknown. We know her older sister, Marie, superintendent of the Cottages for the five years following Mary Erhard's tenure, moved to Washington, D.C., where she worked in the field of human services. But precisely what she did and what ever happened to her is also unknown.

In March 1946, John returned to duty at Naval Auxiliary Air Station (NAAS) Saufley in Pensacola, Florida. He enjoyed the next three years serving as a flight and landing signal instructor at both Saufley and Naval Air Station (NAS) Corry, both in Pensacola. He was promoted to lieutenant on January 1, 1949. In August 1949, he received a transfer to NAS Glenview, Illinois; but by then he had one child, and another on the way, and familial pressure was building to find a less adventurous occupation.

On January 6, 1950, after almost seven and a half years in uniform, he left active duty, accepting a management job with the Travelers Insurance Company. He would not be honorably discharged from the U.S. Naval Reserve until September 1, 1955, giving him a total of slightly more than thirteen years of service to his country.

By the spring of 1951, Betty and John had three children—John Jr., Helen and Elizabeth—and had returned to Sayville. Except for a two-year period from 1954 to 1956, they would never again leave. In 1962, John and Betty also surprised everyone with the addition of twin boys, James and George.

John continued to pay back the community that always meant so much to him. He became very active in church, school and civic affairs. From 1961 to 1965, he served on the Sayville School Board and was president of that organization from 1963 to 1965. From 1962 to 1968, he served on the vestry of St. Ann's Church. He was also an active member of the Sayville Rotary Club.

In June 1976, over a period of a couple of days, he suffered a series of heart attacks resulting in the need for him to become far less active. He completely retired from the insurance business and spent the next twenty-five years enjoying his hobbies, golf and Rotary, serving as the Sayville Club president in 1992. He passed away from a combination of cancer and heart disease in December 2003.

Following the war, Hank returned to civilian life, attending George Washington University's law school and gaining his degree in 1948. In the fall of 1949, Hank went to work for the Interstate Commerce Commission (the ICC) and, in early 1971, joined the Civil Aeronautics Board (CAB) before retiring in the 1980s as an administrative law judge at the GS-16 level. In retirement, Hank moved from Silver Springs, Maryland, to a lovely farmhouse in the "horse country" of Orange, Virginia.

In the late 1960s, Hank's son, Gil, named for Gilbert Albert Whitehouse and also known as "Bud," served as a U.S. Navy hospital corpsman with the U.S. Marines on the ground in Vietnam. As with his namesake, Hank's son worked at one of the most dangerous jobs in the military. Today, Bud's son Christopher, a 2003 graduate of the U.S. Naval Academy, is a navy pilot ordered to San Diego to fly SH-60 helicopters.

In 1948 or 1949, Mary Whitehouse married a salesman by the name of Paul Wilbert Woodcock. The marriage produced five children: Karen Leslie, born May 8, 1950; Brian Eric, born October 7, 1952; Judith Christina, born October 20, 1955; Gilbert (Buddy) Whitehouse, born November 23, 1956; and Lucy Ann, born January 18, 1959. Brian eventually served with the U.S. Army as an MP.

In January 1960, the family moved from the East Coast to Tucson, Arizona, due to their daughter Judy's asthma condition. Paul Woodcock returned to the East Coast, leaving Mary and the children in Tucson. The marriage soon ended in divorce.

For Mary, it was a very difficult time. At the age of thirty-six, with five young children to raise, Mary must have felt completely alone and unwanted. She had been orphaned at an early age, lost her brother closest to her in age in wartime, got discharged from her orphanage at high school graduation and by her mid-thirties was divorced. Finally, she lost close contact with the only adult family members she had ever known, Hank and John. Remarkably, after all that, she gathered her strength and carried on.

In 1962, Mary married Roy Everett Greer, who had two children from a previous marriage. Roy worked as a deputy sheriff in the small town of Ajo, while Mary worked in the intensive care unit at a local hospital and cared for the children. The couple had two more children—Dana Maureen Greer, born August 11, 1961, and Michael Whitehouse Greer, born January 21, 1963. Michael is also a U.S. Army veteran. Mary retired from nursing from St. Mary's Hospital in Tucson in 1972.

In the late 1990s, Mary was diagnosed with cancer, which gradually became worse. Her daughter Lucy says that by the summer of 2001 Mary knew she was dying. When the horrific World Trade Center attack occurred, Mary was devastated, and she asked the family to stop forcing her to eat. She passed away from cancer on September 20, 2001.

BIBLIOGRAPHY

Bradley, James. *Flyboys: A True Story of Courage.* New York: Little, Brown and Company, 2003.

Dickerson, Charles P. *A History of the Community of Sayville.* East Patchogue, NY: Searles Graphics, Inc., 1975.

Gilbert, Price, Jr., Commander, USNR, comp. and ed. *The Escort Carriers in Action: The Story—In Pictures—of the Escort Carrier Force U.S. Pacific Fleet.* Atlanta, GA: Ruralist Press, Inc., 1946.

Gombieski, Jane S. "Kleagles, Klokards, Kludds and Kluxers: The Klan in Suffolk County, 1915–1928." *Long Island Historical Journal* 6, no. 1 (Fall 1993).

Havemeyer, Harry W. *East on the Great South Bay—Sayville and Bayport 1860–1960.* Mattituck, NY: Amereon Ltd., 2001.

———. *Fire Island's Surf Hotel and Other Hostelries on Fire Island Beaches in the Nineteenth Century.* Mattituck, NY: Amereon Ltd., 2006.

Howell, Nathaniel R. *Islip Town's World War II Effort.* Islip, NY: Buys Brothers, 1948.

Johnson, Madeline C. *Fire Island 1650s–1980s.* NJ: Shoreland Press, 1983.

McDaniel, James F., Ensign, USN (Officer in Charge). *The Slipstream Mark IV Edition, U.S. Naval Air Training Center, Corpus Christi, Texas*. Montgomery, AL: Paragon Press, 1944.

Riley, Tom. *Orphan Train Riders: A Brief History of the Orphan Train Era (1854–1829)*. N.p.: Heritage Books, 2005.

Smith, S. Linton, Lt., USNR (under the authority of G.A.T. Washburn, Captain, USN Commanding USS *Lunga Point*). *U.S.S. Lunga Point CVE 94 A Pictorial Log Covering the Ship's Career in the War Against the Axis 14 May 1944 14 May 1945*. Raleigh, NC: Edwards and Broughton Company, 1946.

Stevenson, Charles G. *But As Yesterday: The Early Life and Times of St. Ann's Church, Sayville, Long Island, New York (1864–1888)*. Sayville, NY: 1967.

Taylor, Lawrence J. *Dutchmen on the Bay—The Ethnohistory of a Contractual Community*. Philadelphia: University of Pennsylvania Press, 1983.

Watts, Jill. *The Father Divine Story*. CA: University of California Press, 1992.

Weisbrot, Robert. *Father Divine and the Struggle for Racial Equality*. Champaign: University of Illinois Press, 1983.

CORRESPONDENCE

Lucy Woodcock Spangler
Frances Knight Whitehouse

ORAL CONTRIBUTORS

Adrian Bergen
Bernard Loughlin
Charles Oelkers
Lucy Spangler
Mickey Walker
John Wells
Elaine Kiesling Whitehouse

Elizabeth Whitehouse
Frances Whitehouse
Henry Whitehouse
John Whitehouse

NEWSPAPERS

Brooklyn Eagle
Newsday
New York Times
Suffolk County News

PRIMARY SOURCES

Aircraft of the Smithsonian, Naval Aircraft Factory N3N-3. Copyright 1998–2000.

Appleton, Floyd. "Church Philanthropy in New York—A Study of the Philanthropic Institutions of the Protestant Episcopal Church in the City of New York." Columbia University, 1906.

Directory of Social Agencies of New York, 1924.

Directory of Social Agencies of the City of New York, 36th edition, 1927–28.

Eisenstadt, Peter, ed. *The Encyclopedia of New York State.* Syracuse, NY: Syracuse University Press, 2005.

Helping Hand. Monthly journal of the Church Charities Foundation, Albany Avenue, Brooklyn, New York, 1870–1935.

Inventory of Church Archives in New York City—Protestant Episcopal Diocese of New York, vol. 2, 1940.

Islip Town Census on May 5, 1930, for the Children's Cottages, Sayville Long Island, New York, under the Church Charities Foundation, Inc. of New York City.

Kourier magazine 3, no. 8 (July 1927).

The Long Island Historical Journal. Department of History and the Center for Regional Policy Studies, Stony Brook University.

Newsday. "Long Island: Our Story." Copyright Newsday Inc.; produced by Newsday Electronic Publishing.

New York Charities Directory of 1918.

New York City Fire Museum Director Judy Jamison.

Rectors' Reminiscences 1922–1985, Reminiscences of St. Ann's and of Life at the Rectory. Sayville, NY: St. Ann's Episcopal Church, 1988.

Sayville High School yearbooks, 1929–43.

Scouting in Suffolk 1910–1986. 1987.

Scrapbook by Mary McEnnery Erhard, Superintendent of the Children's Cottages 1930–35. Donated to the Sayville Historical Society by Ronald Erhard; BKCOL 270.

St. Ann's Parish 100th Anniversary Journal. Sayville, NY: St. Ann's Church, 1975.

U.S. Navy Official Personnel Records for Gilbert Whitehouse.

U.S. Navy Official Personnel Records for John H. Whitehouse.

INDEX

A

Ackerly, Ed 64
Adopt a Child Campaign 90
Air/Sea Rescue Boat 679 128
Alameda Naval Air Station 122
American POWs 140
Amityville 76, 103
Antos, Robert 106
Arata
 Joseph 79
 Regina 96
Arlington National Cemetery 123–124
Armistice Day 129
Astor, John Jacob 51
Astor, William Backhouse, Jr. 51

B

baby flat tops 126
Baker, George 70
Bataan 132
Bayard Cutting Arboretum 51
Bay Area Friends of the Fine Arts 40
Bergen, Adrian (Al) 6, 78
Berkeley, Bishop George 113
Berkeley Institute 113, 115, 131

Bermuda Triangle 122
Bernstein, Saul 104, 106
Bond
 Edith 82
 Helen Robb 116, 146
 Joseph (Skipper) 82, 146
 Margaret (Peggy) 82–83
 Thomas 82
Bourne, Commodore Frederick Gilbert
 51–53
Brace, Rev. Charles Loring 31–32
Brando, Marlon 111
Breckenridge, Charles 41
Brookhaven National Laboratory 127
Brooklyn Orphan's Home 34–35,
 113
Brown
 Ann Elizabeth 47
 Mrs. John Murray 53
Brown Field 120
Brown's River 7, 68, 98, 100, 112
Bruhl, Clifford de 63, 96–97
Brush, Dr. George R. 36
Bryan's Bridge 68, 100
Burgess, Right Rev. Frederick 41–43
 and the KKK 77

Bush, George Herbert Walker 130
Butch 98

C

Camp O'Donnel 132
Camp Pocahontas 45
Camp Upton 127
Canon Paul F. Swett Memorial Cottage
 43–44, 94, 96
Capone, Al "Scarface" 76
Carrier Division 29 126
Case
 Everard 97
 Harvey 103
Castle Conklin 9
Catlin
 Helen Robb 113, 116, 146. *See
 also* Helen Robb Bond
 John B. 113, 116, 117
Cecil Field 120
Cedarshore Hotel 23, 75
Central Islip Psychiatric Center 114
Cherry Grove 100–101, 111, 117, 127
Children's Aid Society of New York
 31
Christmas Eve 88
Chubby 96–97
Cioffi, Robert 44
Civil Rights Act of 1871 22
Common Ground at Rotary Park 39
Compton, Betty 14
Congregational Church 74
corporal punishment 64
Corregidor 132
cost per capita 90
Cottage Children's Committee 84, 88
Coysh, Ruth 60
Creighton, Bishop Frank W. 84
crossing the line 130
Cutting
 Robert Fulton 51, 52
 William Bayard 51, 52, 54

D

Daily Parish School 46, 48
Davis, Mary 65–67, 69, 72–73, 77, 80
D-Day 116
Delatour, Dr. H. Beeckman 41
Delavan Hotel 47
Dewey, Governor Thomas 130
Dickerson, Charles P. 14, 75, 111
Dominy House 9
Don McNeill's Breakfast Club 95
Douglas, Rev. Charles 38, 46–49, 54
Dow Clock Field 105
Doyle, Ann 63
draft riots of 1863 30–31, 31
Dr. Eller 101
Durgin, Adm. C.T. 137
Dutch Reformed Church 57
Dykes, Rev. John B. 123

E

Eales, Vernon 105–106
Educational Fund 91
Edwards
 John 36
 Phoebe 36, 38–39
Ellis, Elizabeth Thorn (Lizzie) 55
Ellis Island 10
Episcopal Christ Church 57
Episcopal Church Sisters 30
Erhard
 Mary 28, 44–46, 59, 61–65, 68, 73,
 77, 82–91, 94, 96, 98–101, 106,
 109, 110, 115, 146
 Rev. William Joselin 85, 145
Escort Carrier Force Pacific 131, 137
Evans, Edith Corse 53–54

F

Farragut, David G. 37
Fire Island 9, 50, 56–57, 115, 127
Fire Island Pines 115
First Reformed Church of West Sayvill
 74

Fisherman's Path 115
Five Points Gang 76
Flight 19 122
Floyd, Gen. William 50
Foster, Andrew D. 46–47
Foster House 46–48
Four Hundred Club 51
Fraser, Mrs. Alfred 54

G

German-at-large 14
Gillette
 Charles Edward 38–39, 52, 54
 Charles Zebulon 36–39, 54
 Ida Francesca 36, 38–41, 45, 54–55, 84, 98–99
 Lucille Preston 38–39, 54
Gillette House 37, 39
Girl Scouts 83
Gordon, Edith 111
Gould
 Edwin 45, 84
 Jay 45
Grace Church 29
Grace, Kamartha 65, 67–69, 72–73, 77, 80
Gracie, Col. Archibald 53
Gracie, Sarah 29
Gray House 42–44, 95, 100
Great Depression 23, 44, 62, 78, 87, 100–101, 110
Greene Avenue high school 92, 105, 108
Greene, Isaac H. Jr. 52, 57
Green, Willett 52
Griek, Lawrence 104, 106
Gross Bros. Portrait Shop 19–20
Guadalcanal 125
Guam 138
Gustafson, Clifford 103

H

Hastings, Mrs. George 29
Hatcher, Lt. (j.g.) H.D. 129

Haywood, Rev. Oscar F. (Big Bill) 74
Hoag, Francis 107
Hobbe, Charles 123
Homan, Sarah Elizabeth (Libby) 46
Hook Creek 9, 17, 25
Hubbard, Mrs. Isaac P. 84

I

Indian Neck Hall 52
International Peace Mission Movement 71, 80
Islip 38, 40, 48, 56, 74, 99
Iwo Jima 134, 136

J

Jack Armstrong 95
Jahn, Joseph "Joe" 106–107
Japanese anti-aircraft fire 136
Jedlicka, Joe 104, 106
jeep carriers 126
Jemott
 Herbert 90–91, 114–115
 Margaret 95
Jim Crow laws 67, 70
Jones Beach 84
Jones, Judge Thomas M. 22

K

Kaiser's Koffins 126
kamikaze 132, 134–135, 137, 139
Kennedy, President John F. 124
Kensington Hotel 92
Kiesling Hotel 17
Kim 96–98
King Neptune 130
Knight, Frances 115, 150
Know-Nothings 12–13
Kourier 23

L

Laidlaw, George 97
landing signal officer 120–121, 125, 129, 132

La Salle Military Academy. 52
Lawson, Isabella 47–49
Levering
 Marian 109–110
 Marie Louise 82, 109–111, 124, 146
 Rev. Lewis R. 110–111
Leyte Gulf 130
Littlejohn, Rev. Abram Newkirk 30
Lombardi, Vince 105
Loughlin, Bernard (Barney) 100, 150
Lucille Home for Convalescents 39–40
Luzon 131–132

M

MacArthur, General Douglas 130
MacDonnell, Dr. 101
MacKenzie, "Buck" 102
MacLean, Rev. Peter Duncan 81, 146
Maddare, Lillian 62
Marine Pavilion 9
Marshall Islands 129
Maxfield, Miss 100
McGlynn, Eunice 61, 89, 95, 124
McGlynn, Milton J. 114
Meadow Croft 57, 68, 100
Miller, George 104, 106
Mindanao Sea 131
Minka, Ed 103
Mite boxes 91
Moore, Mr. Rev. 23, 75
Mother Divine 71
Munkelwitz, F.W. 52
Munsell, Nick 100
Munson, Sam 91

N

N3N-3 Canary 119
Nagasaki 136, 140
National Origins Act 21
Naval Air Station Jacksonville 122
Naval Air Training Center 118
Navy Cross 142

Navy Hymn 123
Nemesis 56
New Paltz Normal and Training School
 91
Newport News Shipbuilding 115, 117
New Year's Eve 131
New York Orphan Asylum Society 32
New York University 116
Nick's Clam Bar 99–100
Nohowec, James 52
Northrop Grumman Newport News
 115
Norwegian help 116

O

Oceanside 25, 27, 77
officer of the deck (OOD) 125
Okinawa 136–138, 140
Old '88 92
Olmsted, Frederick Law 51–52
orphans' endowment 90, 99
Orphan train era 32, 57
Otto's Meat Market 50

P

Peace Mission 65, 67, 71, 78, 80
Pearl Harbor 115, 117, 127, 129, 141
Pierrepont, Mrs. Henry E. 29
Pinninah 71–72, 72
Pisani, Nunzio 105
pollywogs 130–131
Polytechnic Preparatory Country Day
 School 113
Potsdam Ultimatum 139
Potter, Bishop Horatio 30
Presidential Unit Citation 142
Prohibition 14, 77–78
PS 158 18, 19

R

residents in the armed forces 117–
 118
Reynolds, Mrs. William O. 84

Richardi, Bobby 96–97
Richards, Mrs. Sarah 29
Riley, Tom 31
Roanoke College 118–119
Roe, Austin 36
Roosevelt
 Edith Kermit 52, 54, 57
 John Ellis 52, 54, 55, 57
 President Franklin 124, 130
 President Theodore 9, 14, 52, 54, 55,
 57, 83, 116
 Robert Barnwell, Jr. 52, 55–57
 Robert Barnwell Sr. 55, 57
Roulston's grocery store 99

S

Saipan 139–140
Sanford, Miss 28
San Francisco 122
Sans Souci Nature Preserve 68
Sayville ferries 100–101
Sayville Fire Department 52
Sayville Food Pantry 40
Sayville Garden Club 39
Sayville Historical Society 37
Sayville Hook and Ladder Company
 52
Sayville Inn 92
Sayville Opera House 73, 111
Sayville Republican Club 39
Sayville Summer Playhouse 111
Sayville Village Improvement Society
 39–40
Schermerhorn, Carolina 51
Sea Dawn 117
70 Sunset Drive 117, 146
Shattuck Military School 110–111
shellbacks 131
Silliman, Ada 101
Silliman, Dr. Grover 101, 104
Silver Star 132–133, 142
Simmons, William 22
Sister Dorothy 28, 43, 82, 85
Sister Lucy 82, 93, 97

Smith
 Al 14
 Cpt. Jacob 38
 Gil 56
 Lewis 80
 William Tangier 50
Snedecor
 Isaac 36
 Mrs. I. Howard 83
SNJ Texan 122
Sparrow Park 38, 40, 92, 99
St. Barnabas's Chapel 46, 48–50
Stein
 Cpt. Fred 100–101, 106
 Edwin (Icky) 106
 Kenneth 106
Stevenson, Charles G. 46–51, 53–54
Stires, Ernest M 43, 84
St. John's Academy 47, 48
St. John's Hospital 41, 93, 101
St. John's University 52
Strong, Roland 101
Subic Bay Naval Station 132
Suffolk County Football League 103
Sulu Sea 131
Sunken Forest 115
Surf Hotel 9
Suydam
 Ann Middleton Lawrence 50
 Ann White Schermerhorn 48, 51
 Helen 51
 John R 46–50
 Walter 51–52
Swett, Rev. Paul F. 32–33, 41, 43
Sykes Beach 100

T

Tammany Hall 13, 14, 76
Terry, Herbert 106
Thuma, Stanley 106
Tiffany windows 54, 83
Titanic 53
Tokyo Bay 141
torp 65, 68–69

Travis, Ruth 59
Travis, Seward S. 92
Troop 16 82
Truman, Harry S 130
Tucker, Richard 79
turtle soup 68
Tweed, William M. "Boss" 13
24 Prospect Park West 116–117, 143

U

United States Naval Reserve Force Section Base 5 55–57
U.S. Grant Hotel 120–121
U.S. Naval Air Station Bay Shore 56
USS *Bismarck Sea* 126, 135
USS *Lunga Point* 125–126, 130–131, 133–143, 141
USS *Makin Island* 126
USS *Ommaney Bay* 132
USS *Salamaua* 126
USS *San Diego* 57
USS *San Jacinto* 130
USS *Saratoga* 135

V

Van Antwerpen, Andrew E. 74
Van Deusen, Claude 26–28
Van Essendelft, Albert 106
VC-85 126, 132, 136–138, 142
VC-98 138–140
Veryzer, John 104, 106
Vinton, Rev. Francis 29
VT-51 130

W

Wachlin, Wallace "Wally" 106
Wakayama 140
Walker
 Jimmy 14
 Louise 91, 95, 101
 Mickey 61, 64, 95, 101, 107, 110, 124, 150
Wallace, Henry A. 130

Webb, Rev. Charles Henry 43, 82, 84, 88, 90, 91
Welton, Bill 104, 106
Wenkmen 104
Wenk, Tillman 104, 105
Wet Pants 98
Whitehouse, Betty 59–61
Whitehouse Hotel 9, 16, 17, 25, 62
Whiting, Rev. William 123
Widow Molly Inn 53
Willett Green and Son 50
William and Mary 91, 105, 114–115, 128
Winston, Dr. 101
Wittmer, Dr. 112
Wixom, Edna 83
Woodcock, Paul Wilbert 147–148
Wood, John 54
Woolley, Beverly 124

Y

Yale, Frankie 76
Yangtze River 139

Z

Zutell, George 34

ABOUT THE AUTHOR

Jack Whitehouse grew up in Sayville, graduating from Sayville High School in 1964. Following college and more than seven years of active duty with the United States Navy, he joined the U.S. Foreign Service, serving abroad for most of his career. In 1995, he and his wife, Elaine Kiesling, and son, John, returned to Sayville, where he and Elaine live today.

Jack wanted to write *Sayville Orphan Heroes* after doing research into the Sayville Cottages where his father grew up. He discovered a typical American town between 1846 and 1946 where, in the context of a small, underfunded orphanage, the true American spirit was defined by hard work, self-sacrifice and concern for the common good.

Jack is the author of *13 Legends of Fire Island and the Great South Bay*. He writes for the *Fire Island Tide* and lectures on the history of Fire Island. In 2010, he won the first place award from the Press Club of Long Island for his regular column in the *Fire Island Tide*.

Visit us at
www.historypress.net